FILMMAKERS SERIES

edited by
ANTHONY SLIDE

In Preparation

Cinematographers on the Art and Craft of Cinematography

compiled by
Anna Kate Sterling

Filmmakers, No. 18

The Scarecrow Press, Inc.
Metuchen, N.J., & London
1987

Library of Congress Cataloging-in-Publication Data

Cinematographers on the art and craft of cinematography.

 (Filmmakers ; no. 18)
 "These essays were first published between
1929 and 1937 in the International photographer"--
Foreword.
 Includes index.
 1. Cinematography. I. Sterling, Anna Kate.
II. Series: Filmmakers series ; no. 18.
TR850.C47 1987 778.5'3 86-31662
ISBN 0-8108-1972-4

CONTENTS

EDITOR'S FOREWORD

Anna Kate Sterling, a young stock footage librarian who is also responsible for an earlier Scarecrow book, Celebrity Articles from the Screen Guild Magazine, has compiled a rich and informative group of essays by cinematographers as varied as Clyde De Vinna, Karl Struss, Hal Mohr, and Ray Rennahan. These essays were first published between 1929 and 1937 in The International Photographer.

There is no better, or, for that matter, logical way to comprehend the work of a cinematographer than through either the lens of his camera or his words. The former is not feasible, but the latter is. Through articles such as those included here, one may learn of the problems involved in location shooting for Trader Horn; statistical information on the filming of Hell's Angels; the introduction of wide-screen and 70mm in 1929; the miniature special effects work on King Kong; and the shooting of Wings of the Morning in England.

Equally valuable are the reminiscences of a group of pioneer cinematographers. G.W. "Billy" Bitzer discusses the filming of Intolerance and recalls other aspects of early motion picture work. Similarly, H. Lyman Broening and Tony Gaudio look back at the teens years. One of the first "film historians" in Los Angeles, the long-forgotten Earl Theisen, documents what he claims to be the first fictional film to be shot in the city--in 1906.

Anna Kate Sterling has put together a volume which will have value not only for the student and scholar of film history, but also both the film student and the working cinematographer, anxious to understand the working methods of the great cameramen of an earlier age.

Anthony Slide

INTRODUCTION

There can be little argument that cinematography is the life
blood of the motion picture, but despite this the cinematog-
rapher has never received anything approaching the recog-
nition given to the director or the screenwriter, or, for that
matter, even the art director. Yet it was one of the great-
est of art directors, William Cameron Menzies, who placed
the cameraman on a par with the director in responsibility
for the pictorial beauty of a film.

Cinematographers have been there since the inception
of the motion picture. Without them, there could be no film.
In the beginning there was the cameraman and he was also
the director. When Edwin S. Porter made The Great Train
Robbery in 1903, not only did he direct the film, but he also
photographed it. In acknowledging the techniques developed
by Porter in the evolution of the motion picture, one is also
recognizing the monumental importance of the cinematograph-
er. He is as much responsible for the grammar of the film
as the director or the editor.

Edwin S. Porter understood the technique of filmmak-
ing, but it is arguable that he was also an artist. A great
or even a good cinematographer must comprehend that the
motion picture is also an art form. The cinematographer
must be both an artist and an engineer, a technician and a
painter in light. It should be not surprising that many
cameramen can admire a painting by one of the great masters
and be able to analyze the painter's lighting techniques as
well as any major art scholar. Their eyes must tell them how
the finished scene will look seen not through the viewfinder
of the camera but projected on a screen.

The cameraman's is a curious profession in that he is

not a photographer, but a director--a director of lighting. As Joseph Walker once noted, "I'm a cameraman, but I don't actually use a camera. The mechanical job of photographing a scene is done by one assistant. Another loads film into the camera. But the two-hour siege of head-scratching that it takes to properly light a 30-second scene--that's all mine."

In that the silent film is primarily a visual medium, it was very much a cameraman's world. Men such as Billy Bitzer, Alvin Wyckoff, Karl Struss, Charles Rosher, Joseph August, Byron Haskin, Karl Brown, Arthur Miller, and Ernest Palmer were responsible for the creation of some of the greatest American films of all times, including Way Down East, 7th Heaven, Sunrise, and The Affairs of Anatol. "Give us a place to stand and we will film the universe" was one cameraman's motto which appeared on the cover of American Cinematographer. With such films as Wings, cameraman Harry Perry proved that the cinematographer could fly as well as stand still. The coming of sound initially halted the camera-man's art since his equipment was confined within a sound-proof booth; in time he escaped, and with films like Applause (photographed by George Folsey) and All Quiet on the Western Front (photographed by Arthur Edeson) regained his rightful place in the art of filmmaking.

It is arguable that a good cameraman can actually save a bad film. A cameraman cannot do anything about the script or the acting. He can ensure that a scene looks at its best, and he can take responsibility for an actor or an actress being seen to advantage. He cannot save what is unsaveable. He can, however, make what is merely common-place special. Without Joseph Walker's lighting and cinema-tography, Frank Capra's Lost Horizon would be a pale imita-tion of its shimmering self. Without William Daniels, Greta Garbo would be far from luminescent. F. W. Murnau's Sun-rise might still be a minor masterpiece without the cinema-tography of Charles Rosher and Karl Struss, but it would not be one of the greatest films of all time. The expression-istic sets cannot come to life without the cameraman's lighting effects, just as the harsh reality of city life in Andre de Toth's Pitfall would be less realistic without the subtle light-ing by Harry Wild.

Directors and stars alike have long recognized the im-portance of the cinematographer. Thus D. W. Griffith

retained the services of Billy Bitzer throughout most of his career. W. S. Van Dyke relied on Clyde De Vinna. Greta Garbo insisted on William Daniels to photograph her, just as Audrey Hepburn required Franz Planer. There was a time in the early 1920s when Lillian Gish could not be photographed by anyone except Hendrik Sartov. Woody Allen's New York is seen to advantage thanks to the continuing camerawork of Gordon Willis.

If the cameraman is so important, why, then, has he not received his due? Why are there only a handful of books on the work of America's cinematographers, and more than a hundred on the careers of America's directors? Laurence Stallings suggests one explanation (in the October 1937 edition of The Stage): the cameraman is associated with the laboring classes. His tools may not be a wrench or a hammer, but even beside a Moy, Debrie, Prevost, Eclair, Pathé, Bell & Howell, Arriflex, or a Mitchell camera, he is a worker. He is a little higher than an electrician or the head propman, but he is several notches below the director, the writer, or the art director. The cinematographer is not a white-collar worker. He is not perceived of as belonging to the intelligentsia--as is the director or the screenwriter--and, therefore, his work is not deserving of similar study or praise. While such an attitude adopted by scholars and students is quite outrageous, there is a lot of truth to its existence: witness the number of students in film schools desirous of becoming writers or directors, and the nonexistence of students seeking to be cinematographers.

"Cameramen rarely break into print," commented critic Harry Alan Potamkin back in 1930. Such, however, is not the case. Cameramen did, quite frequently, break into print--in their own periodicals, American Cinematographer and The International Photographer.

American Cinematographer has been published since November 1920 by the American Society of Cinematographers or ASC. Created as a successor to the Static Club, the American Society of Cinematographers came into being on January 8, 1919, as a professional association for invited cinematographers. With its motto, "Loyalty! Progress! Art!" the ASC has sought recognition for the cameraman and better equipment for his use.

While the American Society of Cinematographers is not a union, the International Photographers of the Motion Picture Industries, IATSE Local 659, very definitely is. Since February 1929, it has published a monthly journal, The International Photographer, edited during its first ten years by Ira B. Hoke, Silas Edgar Snyder, George Blaisdell, and Ed Gibbons. (Snyder had previously been with American Cinematographer and obviously modelled his new journal after the ASC publication.)

From 1929 through 1937, The International Photographer published an important group of articles by cinematographers dealing with both the craft and the art of photography. They discussed work in progress, problems involved in the new three-strip Technicolor process, and reminisced about the early years. These articles were not written by professional writers. They are often flawed and lack the smooothness one has come to expect from a major periodical. There is, however, a gritty, earthy, honest quality to the articles that makes them readable and believable.

Cinematographers on the Art and Craft of Cinematography gathers together the most important articles from The International Photographer from 1929 through 1937. Here is the history of cinematography, presented by its participants, in their own words.

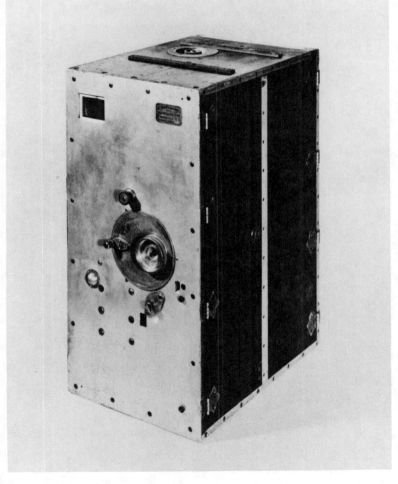

The original Biography camera.

CAMERA ART

by Günther Rittau*

The film in its best productions has established its claim to
be a new pliable medium of artistic expression. But the path
to the perfecting of this new visionary art is long. The cel-
luloid strip was seized to create the first "wonderful, living
pictures"--for the fair-booths. The public was fascinated.
The cinema arose and enticed millions to its shimmering can-
vas. Then there emerged the task of moulding the camera
and the film into a new means of delineating art.

And all who are engaged in this task are apprentices
of the new "camera-art"--for there is no master. We appeal
to the eye by a transient sequence of optical impressions, as
the musician appeals to the ear by an acoustic sequence of
sounds. The lens is our etching needle. We turn backwards
and sweep along the avenues of time; we observe humanity in
all its moods--and discover a new physiognomy. We turn
slowly, and the flowers bloom. We turn quickly, and there
is revealed to us the secret of the bird's flight. We let the
camera swing through space, and observe its dynamics. We
create giants and dwarfs, legendary forests, dragons, and
knights errant. We lead man over the whole earth and point
out to him the grandeur of Nature; and we conduct him through
the secret, tiny places of the microscope.

We have learned to love our camera; and every day we
discover something new and fashion ever richer our scale of

*Günther Rittau (1893-) entered the German film industry
in 1919 and helped photograph Die Nibelungen (1924). Inac-
tive during much of the Nazi period, Rittau returned to film-
making in 1945, working also as a director, and retired in the
late fifties.

expression. Its simple, optical speech has perhaps already
become expressive--like all the other arts. From the play-
thing of the fairbooths there has been fashioned a weapon of
culture, and from this fact arises the duty of the creative
film artist not to profane the rich art of the camera, but to
use it in the service of true culture and international ethics.

--Volume I, No. 5 (June 1929), page 29.

HORNING IN ON HORN

by Clyde De Vinna*

Business Representative Howard Hurd of Local 659 has just received a letter from Brother Clyde De Vinna, written from Nairobi, Kenya Colony, Africa, excerpts from which are herewith presented to the brethren. Brother De Vinna and his associates are on location in Africa filming Trader Horn** for Paramount:

April 25, 1929.

We've been galavanting around pretty much all over the country looking for likely spots for old man Horn to do his stuff, and they aren't so easy to find. As a matter of fact, "darkest Africa" is rapidly becoming settled up, and everywhere are farms and plantations. Only in the outlying districts, accessible by rather extended auto trips, is any "wild" country.... Just at present we're on one of those funny English trains hopping along in the general direction of Nairobi, having been on a week's trip around the Lake Victoria country. Found a few likely spots, but they're rather scattered, and will mean considerable traveling during the course of the picture.... The rainy season has just begun which, of course, is a great help. You should see some of these "roads" when they get about an hour's steady rain on them! The great majority of the soil in the country is red, sort of volcanic,

*Clyde De Vinna (1890-1953) received the second Academy Award for Best Cinematography for his work on White Shadows in the South Seas (1928). He was a long-time M-G-M cinematographer.

**Released by M-G-M in 1931, Trader Horn was directed by W.S. Van Dyke, and starred Harry Carey, Duncan Renaldo, and Edwina Booth.

but now and again they have what they call "black cotton
soil," and when it gets wet there's nearly no bottom to it,
and hitting a stretch of that stuff in the rain means that
you're more liable than not to stay right there.

Haven't been able to do much with the radio set, eith-
er.... Lake Victoria is some puddle, second largest lake in
the world, as a matter of fact, with nearly 28,000 square
miles of water. Inhabited mostly by crocodile and tse-tse
fly. We found a small lake a few miles west of Victoria,
called Lake Navagaba, however, which has some promise as
a location. Will also be going up into the Nile country,
about 300 miles from civilization--also over into the Congo
country, about 250 miles northwest of Kampala. That's in
Belgian territory, but the rest of it will be in British.

The lab is located in Nairobi, about the geographical
center of the scenes of our operations generally and in the
only spot that would fit, so far as physical conditions are
concerned. Nairobi is nearly 6,000 feet above sea level,
and the climate is fine. Fred Meeks is doing his stuff in
great shape, and judging from the appearance of tests al-
ready gone through, I should say that if we don't have a
swell looking picture, it won't be Fred's fault.... The water
supply isn't too good in Nairobi, but Fred has doped it up
with chemicals until he's getting a beautifully clean and even
negative. Mighty glad to have him along.

The rest of the gang arrive in a few days, and we
are more than anxious, naturally, to get all the dope from
them.... Mail is very infrequent down here, and more than
welcome, so for the love of Pete get busy and let us hear
from the boys once in a while....

We go to Mombasa in a couple of days to meet the
gang. That's down on the coast and hotter'n the hinges,
and I'm very much afraid we're going to have to do some
of our river stuff down there. Other locations are near
Nairobi, some 400 miles by rail from Mombasa, and others
are, as I mentioned, in the Lake Victoria country, 500 miles
north of Nairobi, and still others as far as 300 miles north
and west of the lake.... It just happens that in the parts
of the country where the locations are suitable, the natives
are very uninteresting so we will have to find what we can
of the more savage looking birds and transport them to spots

selected.... Many thanks for sending along The Interna-
tional Photographer--very interesting to us to get all the
fresh news.

Please give my very best regards to all the gang, and
tell 'em all to write.

<div align="center">Sincerely,</div>

<div align="right">CLYDE.</div>

P.S.--Our address, M-G-M Company, P.O. Box 981,
Nairobi, British East Africa.

May 6th--

<div align="center">To Ira Hoke</div>

... The rest of the gang got in last week--all looking
and feeling very well. Maybe you think we weren't glad to
see them. Honestly, I haven't done any talking in ages,
compared to the talkfest that ensued after our meeting.
There were so many things to be asked--so many things to
be told--I suspect it sounded like a meeting of the Ladies'
Aid to the outsiders. They seemed to have had a good trip,
but of course were glad to get off the boat. They had
been on there eighteen days from Genoa, and suspect were
about getting fed up with it.

Nogle stayed in Mombasa to photograph a big govern-
ment auction sale of ivory which comes off tomorrow (18,000
pounds of confiscated tusks), and will join the gang at Nai-
robi immediately. He is coming out of his trouble O.K. I
presume you know of the rather serious operation he had on
his face about a month before they left--caused by a tooth.
He was laid up with it for three weeks, but has picked most
of it up again, and looks very well.

Nine of us--Van Dyke, Red Golden, Bob Roberts, Mc-
Afee, Morgan (prop shop), Cornwall (electrician), two hunt-
ers and myself are going out on a scouting trip. Cornwall
will stay at Kampala, which is our advance base, and take
care of the electrical gear when it comes along and he will
be joined later by Riley, the other electrician. Riley had a
little trouble with a tooth, too, and had it yanked out in

Nairobi yesterday. The rest of us will shove along into the
Congo and Upper Nile country to pick out a couple of village
sites, to be joined later by the rest of the gang. We're go-
ing with full "safari"--which is the local term for camping
trip. Have two "hunters," as they call guides here, one of
whom is recognized as the best shot in Africa. Full crew of
cooks and servants, or "boys," as they are called. Each of
the cameramen has a personal boy to look after his tent,
etc., as well as a gun-bearer, who stays right with us all
the time carrying the cannon, and besides that we are each
packing a big Colt. Not that it's particularly dangerous,
but--never can tell.

Communication with headquarters at Nairobi will be
maintained by wireless without any trouble, as we will never
be further away than 1,000 miles or so. I haven't had a real
chance to get through to the U.S. with the set yet. As you
know, it's approximately 14,000 miles, which is more than
enough to tax the capacity of a set much larger than the
one I have. However, given a good set-up, and decent
conditions, I feel that we can get through quite frequently.
Just now, the rainy season is on, and you never heard
such static in your life! The Llewellyn Iron Works is a tomb
alongside it. Will try and send you a few stills as soon as
we get straightened out--everything so far has been a hurry
and bustle, as you can well imagine. Fred Meeks and De-
Cenco, his understudy, have a first class lab. going in
Nairobi, much to the amazement of a number of local "ex-
perts" who forecasted no end of trouble, if not entire dis-
appointment. Fred is turning out negative that would put
many a Hollywood lab. man to lots of grief trying to equal
--and all in all, his end of the trip seems an assured suc-
cess. We're all out to make the greatest picture ever shot--
so stand by for a big treat when we finally get back to
Hollywood. I'm intensely proud of my gang and of my share
in the project--I don't think it's possible to get together a
greater bunch of fellows, or a gang that knows their stuff
as do these boys.

The boys got a kick out of getting the second number
of The International Photographer after they got here--they
arrived a week or so before the gang. She's a peppy jour-
nal all right, Ira, keep her coming! Liked the story very
much indeed.

Let us hear from any of you boys who care to write--
mails are very infrequent, and letters are scarce--so let 'em
come.

Best regards to Howard, and the rest of the gang.

Fraternally and sincerely yours,

CLYDE DE VINNA.

--Volume I, No. 6 (July 1929), pages 16-17.

THE CAMERA BATTERY

by Karl Struss*

In photographing dialogue or talkie pictures, there are various methods in use, depending mostly on the type of story being filmed. In this article we will discuss only the method that was used in picturizing Coquette, on which four cameras were used for most of the sequences.

Previous to the actual photographing, two weeks were spent in rehearsals of all the characters having speaking parts, and at the last rehearsal, the camera positions were determined with the cooperation of the director, Sam Taylor.

The focal length of the lens that each camera was to use was arranged at that time, and notes were made of exactly what was required of each cameraman. The four cameramen were present at the final rehearsals and so were able to follow, with their finders, the complete action of the story as it progressed.

The action was fairly continuous and the scenes ran an average of three or four hundred feet each. Whenever

*One of the best known and most highly respected of cinematographers, Karl Struss (1886-1981) was associated with Clarence White and Alfred Stieglitz as a still photographer before entering the film industry in 1919 with Cecil B. De-Mille. Among his credits are Ben-Hur (1926), Sunrise (1927), The Taming of the Shrew (1929), Dr. Jekyll and Mr. Hyde (1932), and The Great Dictator (1940). He retired in 1970. Struss was the subject of a book-length study, Karl Struss: Man with a Camera by Susan and John Harvith, published by the Cranbrook (Michigan) Academy of Art/Museum in 1976.

the locale or action called for a change, new camera set-ups were mapped out. In working out a line-up, the first camera considered was the long-shot camera, equipped with a lens of 35mm focal length, which obtained a record of the whole action from beginning to end, from the most advantageous position.

The reason for using the 35mm lens instead of a 40mm or 50mm lens for the full figure shot, was to enable the other cameras with the longer focal length lenses, to work closer to the characters, and so, not have to use lenses of say, six, eight and twelve inch focus, with their shallow depth of focus necessitating very accurate measurement of the distance to the characters.

The other cameras using lenses of two, three and four inch focal lengths were then placed to get the best possible view of a certain portion of the scene closer up. All during Coquette,* the longest focal length lens used was the four inch, which at an average distance of about twelve feet gave a fair size close-up. Occasionally there were times when closer silent shots were made, which expressed reactions to the dialogue.

Each line up required different combinations of lenses from various positions, depending entirely on the action and the positions and number of characters in the scene. Sometimes, the cameramen changed their lenses from one focal length to another in the course of a scene in order to adapt their set up to some change in the grouping of the characters.

These changes, of course, were always made at definite times in the action or on certain cues, while the full scene was being covered by some other camera. Each camera was so placed, that when it was used, the best angle of the action was obtained, and the characters were lighted accordingly.

The advantages of photographing with more than two

*Released by United Artists in 1929, Coquette was directed by Sam Taylor, and starred Mary Pickford, Johnny Mack Brown, and Matt Moore.

cameras at the same time are numerous. The actor's action can build up to a climax to much better advantage; the lighting can be arranged to cover the action for all the cameras; the photography can be more uniform and a more even negative, secured; and the sound track, likewise, will be of better quality and of less variable tone. The scene as then photographed is a completed picture.

To facilitate and speed the actual photographing, the chief cinematographer on Coquette supervised the lighting for all the cameras; for, knowing the problems, set-ups, backgrounds and lenses of each camera, he could more quickly judge and decide what was the best advantage of all, and he was not hampered by having to give his time to the detailed attention required to manipulate a camera. Remaining outside of the booths in this way is of considerable advantage to the director, as it enables him to have first hand and immediate information on any photographic problem that may arise from time to time.

The longest scene photographed in Coquette was the complete scene of the trial, which recorded the testimony of Miss Pickford, and on this, six cameras were used; the actual footage being nine hundred ninety feet for each camera, the duration of the scene taking eleven minutes.

This was quite a test for all the actors to know their parts letter perfect, as well as for the cameras to follow the action without a false move, and it speaks well for the organization and cooperation everyone gave.

By being able to photograph all the action simultaneously with six cameras, and from six different viewpoints, it was possible to complete this scene, originally scheduled to take five days, in the short space of two days and without any rush.

The diagram and illustration accompanying the paper, showing objects and areas covered by the various focal length lenses did not arrive in time for publication.

--Volume I, No. 6 (July 1929), page 17.

SHOOTING HELL'S ANGELS*

<div align="right">by Harry Perry**</div>

Seventy exterior and interior sets, providing background
for the ground action alone, were constructed at a cost of
approximately $800,000. Dressing of the scenes, alone,
cost another $70,000, and costumes used by the players
totaled $165,000.

But greater even than the ground operations were the
aerial activities which continued for eighteen months, used
the largest forces of planes and personnel ever privately
brought together and probably flew more war craft than all
other previous war pictures combined.

There were 137 skilled men on the air force payroll,
72 of them pilots and 65 mechanics. The Hell's Angels air
fleet consisted of 87 true war-type planes, half a dozen
camera ships, a giant German Gotha bomber, and a German
dirigible. Among the types bought and re-conditioned for
the picture were German Fokkers, British T. M.'s and
S. E. 5's, Avros, DeHavilands, Jennies and Snipes. It cost
$560,000 to buy and restore this equipment.

Approximately $1,200,000 was expended on the air
flights alone.

*Released by United Artists in 1930, Hell's Angels was di-
rected by Howard Hughes and (uncredited) James Whale,
and starred Ben Lyon, James Hall, and Jean Harlow.

**Harry Perry (1888-1985) was chief cinematographer on
both Wings (1927) and Hell's Angels. He is the subject of
a career article by Oscar G. Estes, Jr. in the March 1960
issue of Films in Review.

The aerial action was conducted in eight different lo-
cales in California, with specially constructed fields, ships
and hangars at Caddo Field, Van Nuys, as a permanent air
base.

At Inglewood, a British training camp was reproduced.
Scenes behind the lines were represented at Encino, and a
German field was maintained at Chatsworth. Flying fields
at San Diego and Riverside were used for other portions of
the story, the Zeppelin's North Sea flight was recorded off
the beach at Santa Cruz, and then for four months at the
great Oakland airport, opposite San Francisco, the greater
combats of the air were pictured with the full fleet of 87
war planes in operation.

From beginning to end nearly one hundred members of
Local 659 were employed on this picture either as cinematog-
raphers or assistants.

Almost two years filming.

Howard Hughes, president of the Caddo Company, the
ruling spirit of the production.

Cost approximately $3,000,000--not hokobolos or co-
pecks.

Forty planes in a single shot.

Two million feet of film in the can.

Here are some statistics from the auditor's books of
the Caddo Company:

Gaetano Gaudio shot the dramatic scenes of the picture
aside from the aerial work.

Incidents of Filming Hells Angels

Al Johnson, stunt pilot, had narrow escape when the
wing of his plane scraped the ground in making a turn close
to the ground for scene at Marsh Field.

George Cooper and Bob Lloyd had near accident when
their plane scraped top of hangar at Marsh Field.

Al Johnson died from burns received when plane which he was taking from Glendale to location at Inglewood failed to clear a high line tension line at Glendale airport, crashed and burned.

Howard Hughes had narrow escape from death when a Thomas-Morse single seater which he was flying for the first time went into a tail spin at location at Inglewood from a height of about 300 feet. The plane was a mass of wreckage out of which Mr. Hughes emerged smiling. He was laid up for about a week with a bad eye and bruises.

Maurice Murphy had a forced landing at Inglewood because of a bad motor. He was later killed in a crash at San Diego while flying a Maddox plane.

Ralph Blanchard, technical director at the start of the picture, was killed in a home-made plane after leaving the employ of Howard Hughes.

Ross Cooke had a crash at Santa Paula location and British type S. E. scout was washed out.

Al Wilson lost a prop from the German Fokker which he was flying over fog above Hollywood and jumped with a parachute. He alighted on the roof of a house close to Hollywood Boulevard and LaBrea; plane landed in Joe Schenk's back yard, two blocks from Grauman's Chinese Theatre.

Roscoe Turner brought a big two-motored bomber across country from New York to Caddo Field in the San Fernando Valley. He went into a tail spin over the San Bernardino Mountains and narrowly missed crashing. After changing ship over from passenger ship with capacity of twelve passengers to German bomber, it was tested at Caddo Field and Roger Manning, technical director, narrowly missed serious accident when he was knocked down by a prop blast and tail skid narrowly misses his body.

Jack Rand had a landing gear buckle in landing after a shot in the air and the plane turned over on its back.

Frank Clarke did a ground loop at Long Beach and broke a wing and prop.

Roscoe Turner took up a Ryan monoplane belonging to Roy Wilson with Ben Lyon as passenger, to fly to the Breakfast Club. While circling there they ran out of gas and were forced to land in the Los Angeles river bed, where they crashed and turned over, but escaped injury.

A bomber landed at Rogers Field and broke a wheel, holding up work for several days.

A scene was made of a bomber by about five cameramen and Howard Hughes on a 20-foot parallel, photographing it coming straight for them with motors going. There were about forty men on the ground to stop the bomber before it reached the parallel, but it took them along like they were nothing and the only thing that stopped it was a large twelve-foot log right at the foot of parallel. A tragedy was narrowly averted.

In attempting a shot of the bomber taking off two cameras worth $8,000 were smashed and scattered over the field when hit by landing gear and propeller. Harry Perry and Jeff Gibbons narrowly escaped being killed when part of a broken prop whirled by their heads. Also Elmer Marcy, mechanic, had a narrow escape when a piece of prop went through the nose of a bomber where he was riding. The bomber ended up in a plowed field and was laid up a week for repairs. Mr. Hughes, who was playing golf, was notified by phone, and the first thing he wanted to know was if the film was all right. When told that it was ruined, as the magazines were smashed to pieces, he said: "Well, I'll be out when I finish my game"--which apparently was more important than a $25,000 loss.

Phil Phillips, a Hollywood flier, who formerly was employed by the American Society of Cinematographers as assistant business manager, was killed while taking a British S. E. 5 from Hollywood to location. At his destination he apparently ran out of gas and to avoid crashing into a grove of trees he made a bank with the wind and lost flying speed and dived into the ground. Phil was a fine boy and evidently sensed an accident before he left the Caddo Field where he had molded a little grave and put a silver tin foil cross on same at spot where he sat talking to Schechel, the field watchman, while his ship was being warmed up.

Frank Tommich was sent down from Oakland to bring up another S. E. 5 to take the place of the one smashed and was five days getting back on account of bad winds. While in Oakland, where we were attempting to get the biggest and most expensive scene ever made for pictures, we had many forced landings and several crashes. This scene will run only about 100 feet in the picture and cost $100,000 to get. It consisted of fifteen white ships, representing the British, and sixteen black ships, representing the Germans. These two groups are shown coming together and engaging in a dog fight around the bomber, and was photographed with cameramen in four other ships and several automatic cameras on ships in scene. This shot took two months, including two weeks' rehearsal, before being done satisfactory.

One day a plane flown by Jerry Andrews was run in to by another plane, pilot unknown, and the upper part of Andrews' upper wing was ripped off, but he made a successful landing.

Another day two planes, pilots unknown, came down with the ends of wings smashed. Another time a plane flown by Stewart Murphy crashed into one flown by Ira Reid. Murphy used his parachute successfully, but his ship was washed out. Reid brought his down with the lower right wing knocked off.

While coming back from Oakland three Fokkers were washed out through forced landings. They were flown by Ross Cook, Ira Reid and Earl Gordon, none of whom were hurt.

While attempting to spin the bomber for a scene being shot from three camera ships it went out of control of Al Wilson, who was forced to jump from a height of 5,000 feet. Phil Jones, mechanic, who was in the cabin of the bomber, was killed in the crash that followed and the bomber washed out.

Burton Steene, Akely cameraman, who photographed aerial scenes throughout the picture and who photographed the bomber as it fell, had an attack of heart failure next day and passed away about a week later. Steene had suffered from heart trouble for several years unknown to us fellows on the picture, for he never complained.

Roy Wilson, Earl Gordon and Ira Reid all had forced landings on the same day.

O'Toole was badly hurt by a prop at German field location and laid up. A month later he was killed in an airplane accident, but not on the picture.

Roy Eilers was hit by a bomber prop and laid up for a week.

Following are approximate flying hours by cameramen, actors and pilots on Hell's Angels: Burton Steene, 200 hours; Harry Perry, 175 hours; Elmer Dyer, 50 hours; Ben Lyon, 75 hours; Jim Hall, 65 hours; Roscoe Turner, 300 hours; Frank Tommich, 350 hours; Frank Clarke, 450 hours; Earl Gordon, 150 hours; Ross Cook, 150 hours; Jack Rand, 150 hours.

--Volume I, No. 6 (July 1929), pages 31-32.

THE COLOR CAMERA OUTDOORS

by George Barr Brown

The history of Hollywood could be written around the motion picture camera, just as vividly and dramatically as the cinema film unfolds to the world pulsating human stories, powerful spectacles and events of interest that take place in the remotest corners of the globe.

A new chapter has been added to this modern romance of our mechanical age. And William Rees, of Local 659, one of the youngest directors of cinematography in the industry, plays a leading role in this newest romance of motion picture photography.

Color photography, developed by Technicolor, is an interesting chapter in the fascinating advancement of cinematography. The production of feature length talking motion pictures filmed entirely in natural color is hailed as the most important individual contribution to the screen since the movies first acquired a speaking vocabulary a little over three years ago.

Although color has been known to the screen for many years, it is only within recent months that it has acquired outstanding importance in film manufacture. To the Warner Brothers is given credit for the first all color talkie of feature length ever to be shown, On with the Show.

However, an all talking, all color feature, produced in the great outdoors, presented new difficulties never before encountered by producer, director, players, or cameramen. Once again the Warners pioneered in making Under a Texas Moon, featuring Frank Fay, Myrna Loy, Raquel Torres, Armida, and others, an all color, all talking special filmed in natural locations. William Rees was assigned director of

cinematography. Michael Curtiz, who made Noah's Ark, was
entrusted with the direction.

With cast and story ready for production Curtiz and
Rees chartered an airplane. From the air they traversed
practically every square mile of Arizona in search of suitable
locations. For three days they looked from the skies down
upon the wilds. But their quest was fruitless.

Finally Victorville, Red Rock Canyon and Palm Springs
Canyon were selected as suitable spots. The coloring of the
land and rocks lent themselves admirably to color photogra-
phy.

In addition, huge sets were constructed on the Warner
Ranch, formerly the Lasky Ranch, where a major part of
Under a Texas Moon was made.

The first day's shooting brought about a revelation in
motion picture photography. Rees and his staff of assistants
learned many things and their ingenuity is responsible for
innumerable difficulties being over come.

In the first place, color makeup on the players went
under stringent tests. As there were several white charac-
ters in the cast, the majority of whom played dark skinned
Mexicans, a contrast in complexions had to be maintained.
This was accomplished by throwing more light, by indirect
means with either reflector or lamp, on the faces of those
enacting Mexicans. Their color tones were, therefore, regis-
tered heavier on the color film.

Variation in angle of the sun's rays brought about un-
foreseen problems. As the sun gradually sets in the west
its rays strike tiny particles in the air causing a red "over-
coat," which is a distinct vermilion glow even noticeable to
the human eye. This red tinge distinctly registers on the
color film, throwing a reddish haze over the entire picture.

It was impossible, therefore, to photograph with sun-
light late in the afternoon. Rees found it possible, however,
to continue work by the use of a large black silk overhead
diffuse. The complete elimination of direct sunlight did away
with the red "overcast." In other cases, he found it advis-
able to throw in a few incandescent lamps in addition to the
overhead diffuse in order to insure photographic matching.

In other cases, also, old Sol played havoc with established motion picture traditions. With the changing of shadows on rocks and other natural backgrounds, the cameramen found more food for their inventive minds. They could not linger with the taking of such scenes, as the colors of the rocks and surrounding country changed with the moving sun and shadows. Speed was necessary. When for any reason, the takes were not satisfactory, and the scenic backgrounds assumed different hues than formerly photographed, it was up to Rees to improve on Mother Nature herself.

In these cases, incandescents took the place of the sun. However, they had to be placed exactly as the sun itself formerly shone on players and backgrounds. No little maneuvering of the special Technicolor glass, monotone filter, was necessary to match incandescent lamps with the sun's rays.

This was not the only case where man improved on nature or moved the old Dame about to comply with his needs.

It was found that nature made no mistake in choosing green as her basic and most prominent shade. Technicolor reproduces green and blue-green in gorgeous hues, but no definite and distinct individual blue registers itself. Hence the studio painters did themselves proud with green paint. Like the artist who painted the lily, they painted the desert palm trees a vivid green. Other brush and shrubs was tinted with the painter's green as well.

Constantly by the side of the camera tripod, a standby painter remained at the beck and call of Cinematographer Rees. it was necessary to keep him on hand as many time spots had to be touched up, trees given a delicate daub here and there, and many unsuspecting places revealed themselves in the monotone filter.

Oftimes as many as six cameras were lined up on a single setting. Each revealed defects in coloring that the other did not pick up, and the painter in such cases worked overtime touching up places in respect to each separate camera. Even brightly colored flowers were planted in the desert scenes to add luster to the desolate wastelands.

Various shades of purples, as mauve, lavender, orchid,

and so on, do not register, it was discovered. Whenever
these tones are used, either in costumes or sets, the result
on the negative is a muddy gray.

Nature's fickleness in her changing moods, caused
Rees to resort to other artificial methods on numerous occa-
sions during the making of Under a Texas Moon.

Many times it was necessary to cut out all sunlight en-
tirely. Artificial lighting was found, at certain times of the
day, to facilitate more even tones of colors. This was par-
ticularly true with "closeups" of the players, where even
shades were demanded for each type throughout the entire
production.

But even the incandescents presented their problems.
The strength of the illumination could not be too hot or too
soft. A happy medium was needed. If the lamps were too
soft, the quality of the color suffered. If they were over
hot a white streak greeted the eye in the projection room,
instead of even color tones. In back-lighting "closeups"
particularly, the players had to be lighted with infinite care
so that the light rays were not too hot to produce a white
light streak.

While the heat in a talkie camera booth is hot enough
for any desert sheik, sufficient lamps to illuminate a color
scene causes almost unbearable heat upon the players.

Here Rees was able to make things comfortable for the
artists. When shooting at the Warner ranch, he was forced
to use sets of incandescents. Aided by the summer time heat
of California's sun, a high temperature was generated. So,
Rees ordered his electricians and grips to organize an indi-
rect lighting system. By focusing the lamps on reflectors,
rocks, and even light pieces of cloth material, the heat of
the lamps was greatly decreased while little of their illumin-
ating power was wasted.

So far as photographing such an outdoor sound picture
as Under a Texas Moon is concerned, there is little difference
in regard to synchronization except for a few isolated in-
stances peculiar to color cinematography.

Color cameras, which make a far greater noise when in

motion than an ordinary black and white camera, must be placed in special booths. The newer blankets, "bungalows," and boxes over the camera head, do not furnish sufficient sound deadening for the sensitive microphones.

--Volume I, No. 8 (September 1929), page 34.

A LETTER FROM DONALD [J.] BELL

Brawley, California.

Mr. Silas Edgar Snyder,
Editor "The International Photographer,"
Hollywood, California.

Dear Sir:

Responding to your very complimentary invitation to present, through your publication, a review of my activities and engagement in the cinema industry, the following is offered:

Throughout the many happy years of my business life the desire to do something worthy and beneficial in the chosen line of my endeavor has always been uppermost.

The Magniscope

The beginnings of my activities had much to do as an influence upon my purposes of the later years of effort, so first I must tell my beginnings. Arriving in Chicago, October 1, 1896, employment was secured as chief usher in the Schiller Theatre, on Randolph street. There we had the Lumiere Cinematograph, to me intensely interesting, but my desire to see the machine and become familiar with its operation was not satisfied as entrance to the booth was denied to all.

This Cinematograph was followed by George K. Spoor with the Amet Magniscope and its installation was to be my opportunity. The Magniscope required the services of an operator and an assistant, so in furtherance of my desire to learn the operation of motion picture projectors, I suggested to Mr. Spoor that he could secure my services at a nominal amount instead of full pay to an assistant.

I Land a Job

My suggestion was well received and my name was
placed on Mr. Spoor's payroll, giving me the desired oppor-
tunity to become an operator. Many questions were asked of
the operator, with the answers carefully recorded in my little
book and, as I became familiar with the machine, the oper-
ator allowed me to carry the key to the booth, on my promise
to keep the booth clean and have his show ready. This
privilege and the kindness of the stage electrician provided
means to the end I sought, and it wasn't long until I had
the job of operator at the Schiller.

Mr. Spoor had a booking agreement with a small the-
atre in Waukegan, Illinois; my first experience as a "projec-
tionist" was there. The Magniscope was mounted on a plat-
form supported by beer barrels borrowed from a nearby sa-
loon. The electric supply was a "cut-in" on street light
series arc circuit direct to the lamp without resistance, on
account of low voltage. The streets were nearly dark in
Waukegan that Saturday night on account of my demand
made on the series arc circuit.

Limited Film Supply

Much could be told of my first few experiences as an
operator when the art of cinematography was new, but my
most impressive recollection is that even then the necessity
for a definitely fixed standard was apparent to me.

The source of film supply was limited to a few Ameri-
can, English and French studios. All perforations, however,
differed as to gauge of all dimensions, necessitating actuating
means of sprocket or shuttle action so that they would en-
gage any or all perforations. Correct registration was im-
possible and the moving picture projector soon came to be
known as the "flickerscope."

Our Early Feature

On this account moving pictures were not popular after
the novelty ceased and the engagements were few until some
actual, and many fake, pictures of the Spanish-American War

were available. About this time Mr. Spoor secured an en-
gagement at a music hall in Chicago and during this time
the Maine was blown up in Havana harbor. Soon thereafter
pictures of the wreck were available and after the beginning
of the Spanish-American War some actual and many fake pic-
tures, including Lubin's Charge Up San Juan Hill, with
Roosevelt, were offered. These pictures would now look
very ridiculous to our movie audiences, as they were indeed
very crude. The increased demand for films made produc-
tion profitable and brought out many interesting short sub-
jects, scenics, illusion and comedy, and some short stories.

The two outstanding feature pictures of 1896 were The
Empire State Express, produced by Biograph, on 70 mm.
film, time thirty seconds and The Cavalry Charge, by Lu-
mieres, on the cinematograph, time about fifty seconds.

The Optoscope

During the year 1898 MacMillan made the Optoscope,
sold principally by Sears, Roebuck and Company. Mr. Spoor
bought one for inspection and trial. This machine consisted
of a small cast iron box, two gears, a driver geared direct
to pinion on camshaft, barrel shutter, hard rubber sprocket,
lens fixed to box and sliding aperture operated by finger
movement for framing, a two pin cam necessitating large
shutter area effecting a distressing flicker.

The First Kinodrome

Mr. Spoor was, at that time, superintendent of the
parcel room and news agency at the old Northwestern Pas-
senger station, Chicago. He gained permission for me to use
the machinist tools and bench at the station power house.
Here the Optoscope was remodeled to make it practical for
exhibition purposes. The lens and aperture were tied to-
gether and fixed to a substantial mounting and the mechanism
was made to slide in this mounting to effect correct framing.

This machine was the first Kinodrome. My first en-
gagement with that was at the County Fair at Beaver Dam,
Wisconsin, in the fall of 1898. A favorable telegraph report
to Mr. Spoor led us in to the Great Northern Theatre at

Chicago and thereafter we had continuous booking for this machine and four more remodeled Optoscopes, under the name of Kinodrome.

Kinodrome Improved

One of these engagements took me to Shubert's Grand, at Syracuse, New York, where the first Kinodrome of my own design was made during the winter of 1899-1900. Sunday was a dark day in Syracuse theatres, so this day was chosen for my try-out. It would take many paragraphs to tell of my construction experiences, but suffice it to say that my months of work had a happy ending.

Mr. Shubert and his stage manager were asked to enter the theatre to see my next week's show and this show was projected by my new machine. Both exclaimed: "What have you done to the machine?" After being shown my new machine, Mr. Shubert at once offered to finance the making of ten on a fair partnership agreement, but to me it seemed that in fairness to my employer, Mr. Spoor, I should give him the first call, so we two later on entered into an agreement under which we operated until 1908.

Business Picks Up

It may be interesting to some to learn that during this engagement at Syracuse, our program carried a wonderful picture of Dewey's fleet entering New York harbor. This picture was well received until Wednesday of that week when publication was made that Admiral Dewey had given to his wife the house in Washington, D.C., which had been presented to him by the school children of the United States. After this the picture was hissed and it was necessary to remove it from the program.

Our success at Syracuse and several theatres in Chicago brought great popularity to the "Spoor Kinodrome Service" and our business grew very rapidly, our engagements being vaudeville houses during the winter season and amusement parks during the summer.

Our business getting efforts were confined to the

territory west of Cleveland, but, John Rock of the Vita-
graph, in some clever way "edged" us out of a summer en-
gagement at Saginaw, Michigan, so by way of retaliation I
had the pleasure of assisting his Vitagraph operator to pack
up at Wilmer & Vincents (Utica, N.Y.), Theatre shortly after
their opening the following fall.

This business so continued until the establishment of
the moving picture theatre. The business was not on a
very high plane in these earlier days and I recall the in-
cident of a manager from Marion, Ohio, coming to the Spoor
office to engage service for his new forty thousand dollar
theatre. Our price for operator, machine and one thousand
feet of film for a weekly program was forty dollars. This
price seemed very high to the manager and to justify our
price the first explanation given was that the operator re-
ceived $15.00 per week. To this explanation his reply was
that "he could get any boy in town to run the picture ma-
chine for two dollars weekly and the privilege of seeing the
show." It should be added that Mr. Spoor did not receive
the contract for this new theatre.

Meets Albert Howell

My first introduction to "Bert" Howell was in the Crary
Machine Works, at Chicago, where this shop made many parts
for my Kinodrome projectors. My machines were really very
crude in design, although quite practical and accurate. Mr.
Crary kindly suggested that Bert could be a valuable aid
to me as he was a competent draughtsman and a skilled me-
chanic. At this shop opportunity offered to witness Mr.
Howell's very clever work on automatic machinery so, gladly,
his services were accepted, the result being a fine redesigned
machine following the details of a complete set of drawings
from Mr. Howell's board.

Bert's experience in my work set his ingenious and
prolific mind to work and one day he referred a drawing to
me which showed that he was deeply interested in my line
of endeavor. It was the drawing of a structure for which
he had applied for a patent, it being the new and novel
means for framing by cleverly swinging the cam on an axis
to the star wheel, thereby advancing or retarding the inter-
mittent sprocket to effect framing. This structure was used

by the designers of Simplex who, at that time, did not know
of its use on Kinodrome, as the Kinodrome had never been
used in the New York City territory.

B. & H. Company Born

This display of talent by Mr. Howell convinced me that
in order to avoid competition from his efforts it would be
well to establish a company wherein Mr. Howell would have
a substantial interest, so the Bell & Howell Company was in-
corporated January 1, 1907.

Automatic Machinery

Our plans were to manufacture my Kinodrome machine
and to attempt the manufacture of automatic machinery. In
all seventy-five new model Kinodromes were made, but most
of the number were put into my shop vault, as our projec-
tion business suffered after Mr. Spoor established Essanay
films.

We made an automatic machine, a very efficient one,
producing three thousand strawberry boxes per hour at a
cost to us far in excess of contract price and sold by us
under execution at a junked price in an attempt to satisfy
our account for its manufacture.

"Funny Little Things"

About this time, Mr. Spoor, who had established the
Essanay Company, came to us with a printer, perforator and
other film production machinery purchased in England for
the use of the Essanay films. All were crank operated and,
in fact, almost toys. At that time it appeared that no one
had attempted the manufacture of cine-machinery to supply
the trade. "The funny little things" which we were asked
to make practical were a revelation to us so, as happily I
had the financial means to attempt my fondest hope for the
industry--Standardization, and having full faith in Mr. How-
ell's ability, it was decided that our company should engage
in the manufacture of cine-machinery.

Standard Perforator

My years of experience as an operator and designer
of projectors established in my mind the paramount necessity
of producing a standard perforator, this to be our first de-
velopment toward effecting standardization of all motion pic-
ture producing machinery. We gathered together a great
number of film samples of all makes and as many different
intermittent sprockets as were obtainable. A very careful
analysis was attempted resulting in what appeared to us as
being the most nearly correct as to dimensions to adopt as
standard. Our computation figures indicating the basis of
our conclusions and why the B. & H. perforating gauge was
adopted would possibly be dry reading, so will not be given
herein.

Most certainly Mr. Howell joins with me in the belief
that the design and making of a perfect perforator, effecting
the beginning of standard cine-machinery has been an im-
portant factor and of lasting benefit to the moving picture
industry now resulting in perfect projection, and that this
machine, our first undertaking, was our most important of-
fering to the industry.

B. & H. Standard Camera

Following the perforator, the development of a B. & H.
Standard Camera was attempted. Accuracy, close to our
established standard, was our aim. The first two cameras
were splendid instruments. One was purchased by Essanay
and one by Kalem Company, of New York. After the first
cameras were well along in work Mr. Howell's ingenious mind
began to unfold, releasing many novel features for an accu-
rate and efficient camera, resulting in the production of
B. & H. Professional Model, now so well known throughout
the world.

Many of the trade said that one thousand dollars could
not be put in that small box, tripod, one lens, one magazine
and carrying case, but the fact is that at that price, after
two per cent, ten days, was taken on cash sales, the books
of our company showed that our loss on the transaction was
$1.92.

Now the trade is more liberal in their opinion as they
are willing to pay several thousand dollars for one camera
equipment and offer no complaint. Unusual were among those
who could not associate the amount of one thousand dollars
with Camera Perfection Language, so it was not until 1915
that they were convinced by demonstration, we having re-
called that the old "Proof of the Pudding" talk might taste
fine to the management, so a B. & H. was given into the
charge of Klaffki, our only observance being it should be
used for a complete production. Klaffki "rushes" soon
brought demands from all directors on the lots for B. & H.
cameras.

The above may sound much like a Bell & Howell Com-
pany advertisement or a testimonial to Mr. Howell's ability
rather than a tale of my experiences in the industry, so I
will modestly claim a good share in the early efforts we both
gave to our undertakings.

And, though not being a skilled mechanic, a certain
amount of native ingenuity and imagination was helpful to
our promotions and a determination to be helpful and fair
to our trade in our advices and business methods had much
to do with our success and balanced our usefulness to the
company quite evenly and I may claim with pride that, at the
time my interests in Bell & Howell Company were sold to the
present owners, the business was built on a very solid
foundation, having a world-wide reputation for excellence
so the new owners' path to the great success they have made,
had previously been made smooth.

Redfield's Condenser

Reverting to early experiences, those of my engage-
ments as operator and, later, as employer of operators, hold
memories of instances, many amusing and some distressing,
as my projection business with Mr. Spoor grew more rapidly
than operators could be developed. Many of my boys became
capable rapidly and, of course, some never could quite get
the right line-up for success.

Before the advent of the movie theatre, many exhibitors
sent out what we call "road shows." It is recalled that we
sent Frank Redfield out with San Francisco earthquake

pictures, but in our haste to get this show out, the con-
densers for the lamp were overlooked and his opening show
too far from home to correct this mistake. At dinner in the
American Plan Hotel, Redfield found a round water decanter
on his table. Fortunately the sun coming through the win-
dow reached this decanter and Redfield at once noticed the
rays condensed on a menu at the opposite side of the table.
This ingenious operator immediately determined to try this
decanter to replace his condensers and this was done by
permission of the hotel manager and Redfield gave his show
that night.

Chester N. Sutton, now manager of Mason Opera House,
Los Angeles, was one of our first operators, he having
served his apprenticeship with me at Syracuse, his home
town in 1900. His first engagement was at Lake Erie Cosmo,
Toledo, Ohio, and his first mistake was to connect his booth
incandescent to a 500-volt circuit, resulting in a beautiful
display of fireworks. Chester still calls me boss, and I will
testify he can still qualify as a projectionist--although he
soon left our employ to become manager in Orpheum Company
employ.

Kinodrome Road Show

Mr. Spoor sent out a Kinodrome show with twenty-two
pieces of baggage. This baggage included six Roman chari-
ots, street banners, banners for horses driven in tandem and
considerable advertising matter. Arriving at a small Iowa
town, Mr. Jules Bistes, the operator, contacted the local
manager, who it appears was the transfer man, the consta-
ble, the piano player and about everything in the small town.

Jules gave the manager twenty-two checks for bag-
gage, but as the operator and the trumpeter for the parade
were the only ones to alight from the train, the manager in-
quired:

"Where is the troupe?"

Jules, pointing to a small heavy Taylor trunk, con-
taining the film, told the manager that the troupe was in the
trunk. This hardly satisfied and an emphatic demand was
made to learn when the troupe would arrive, and so on until

our rube friend was made to understand that Kinodrome show
was moving pictures.

Carl Laemmle's Start

Sometimes I wonder if dear old Carl Laemmle remembers
the time when I, acting for Mr. Spoor, ran off many hundreds
of feet of old film subjects for him at Spoor Company's office,
and which he purchased at a very low price. We thought he
had purchased lemons and Mr. Spoor was glad to get the
money, but soon it was apparent that Mr. Laemmle was the
wise one, for his "junk," added to a quantity of new film,
placed him in a position to cut heavily into Mr. Spoor's film
rental business and this was the start of the great Laemmle
moving picture enterprises.

The Motion Picture Patents Company was formed about
the time of the beginning of our Bell & Howell enterprise.
Our first productions were sold to the licensees of this com-
pany only on the assurance given by Mr. Spoor that on
these sales we were not infringing on any patents claimed
by the Patents Company. While on its "death-bed" this
company made a claim against us for infringement, asked
many thousands of dollars from us, and gladly took one
thousand, which was paid to avoid further annoyance. Mr.
Spoor took the license for my Kinodrome in his name and I
paid the royalty.

Meets Bill Fox

It seems that William Fox, now a big figure in the in-
dustry, was the only one who successfully combated the
Patents Company and its child, The General Film Company.
This reminds me of my introduction to Mr. Fox by Doc Wil-
lett in the Men's Grill at the Claridge on Broadway, New
York. Through the business relations between our com-
panies, Mr. Fox knew Bell and Howell, but our introduction
brought a laugh to Mr. Fox, his first smile since Herbert
Brenon made Neptune's Daughter with Annette Kellermann,
Mr. Fox explaining that he had always pictured me in his
mind as one of those long-bearded fellows like Nicholas Power,
designer of the Camerograph Projector.

It has always seemed to me that the trade owes much
to Mr. Laemmle, as he was probably the most active in liti-
gating the claims of the Motion Picture Patents Company and
I am led to believe that Doc Willett, while in the employ of
"IMP," Mr. Laemmle's first production enterprise, was very
helpful and an important factor in "IMP's" production. Doc
is the son-in-law of the late William Rock, one of the "Li-
cense Bunch." Doc left a monument to his name when he
quit the industry, Willett Laboratories at Fort Lee, New
Jersey.

Beginnings of S. M. P. E.

Who recalls by whom and when was the Society of Mo-
tion Picture Engineers first suggested. Frank Cannock, de-
signer of Simplex Projector; Mr. Howell and myself were
having dinner one evening at the Hermitage, Forty-second
and Seventh avenue, New York. If my recollections serve
me correctly, I was the one at that time and place who
suggested it was timely to endeavor to form the society that
now so efficiently and intelligently works for the betterment
of the cinema industry.

The December number of The International Photograph-
er discloses to me three very interesting articles, ably dis-
cussed and cleverly illustrated: First, the Super Simplex;
then references to George K. Spoor's activities and Mitchell's
buckle proof magazine.

Because of my many years of friendly and interesting
association with the designers and promoters of the remark-
able projector Simplex, it is particularly pleasing to me to
note that Simplex is the first to adopt my idea of correct
position for the shutter. I most certainly shall seek an early
opportunity to see the Super Simplex. It is also interesting
to note that the Mitchell Camera Company has adopted my
film take-up tension regulator which I designed and used on
my Kinodrome projectors beginning about 1902. Mr. Jonson's
illustrated article discloses that Mr. Mitchell uses spring ten-
sion, while on my take-up, an adjustable counter weight was
employed to gain the correct balance between the constantly
increasing film tension and the spring drive belt, the counter
weight proving to be more effective on the lower magazine
takeup than spring tension.

The pictures above your "Chicago Six-Sixty-Six" department and the subject matter take me back to the very beginning of my cinema experience, the Magniscope disclosed by Mr. Spoor being the one on which I received my first tuition. The hardwood "gated spindle" upper film holder on the Magniscope disclosed is the one I made and attached, this being my first mechanical work on a film projector.

The Magniscope was designed and made by Mr. Ed Amet, then of Waukegan, Illinois, but now of Redondo Beach, California. Mr. Amet's first projector, the companion to the one disclosed, is now in an honored position at the Smithsonian Institution, Washington, D.C. The operator of this first Amet Projector, Mr. Amet's brother, is now residing here in Brawley, California. Mr. Spoor did not design or make the Magniscope.

The picture of Essanay's first perforator and the printer, as illustrated in this article are familiar faces, they being the "funny little machines" previously referred to herein.

Mr. Howell's first camera is correctly disclosed. True, the box was rather large, but it was a splendid instrument and its use by Essanay brought very favorable comment on the excellence of that company's photography. Now that the cinema industry may endure the cost necessary to conduct engineering and development of cinemachinery, to process a greatly enlarged film, there most certainly will be a great advancement in the art and my sincere hope is that Mr. Spoor's engineers will bring their activities to a successful conclusion and that along with the recording of natural color and the human voice will be the third dimension: to add to the beauty of moving pictures.

Let us all hope that those who are now devoting their talents and millions of dollars to special machinery to employ the use of a wider film will get together and adopt a certain definite standard as to all dimensions and details; then possibly within a few years the use of the 35 mm. film may be discarded and our movies may be a thing of beauty forever.

Here in my fine little home town I find much happiness in my agricultural developments. Some of my friends have heard that I have "invented something to take the flicker out of motion pictures," but I shall not attempt to explain

my present connections with the cinema industry as the
story would hardly be interesting to those not conversant
with the subject.

One may be just as active and helpful in a small town
as those having residence in metropolitan areas. We have
everything they have, although not so pretentious, so with
my own business affairs, Chamber of Commerce, County
Board of Trade, Country Club, etc., I am very happy here
one hundred and twenty feet below the sea's level.

<div style="text-align:right">

Faithfully your,
Donald J. Bell.

</div>

--Volume II, No. 1 (February 1930), pages 18-21.

70mm FILM VERSUS OTHER SIZES

by George A. Mitchell*

A few old facts presented anew.

Wide film is old. The mere use of wide film is no
novelty. Many have advocated its use in the past, and
have pointed out its many advantages. There have also
been others who have been careful to point out its disad-
vantages and until recently the latter have made the most
progress with their argument.

The cost of changing the equipment was looked upon
as an insurmountable obstacle. It took the talking picture
to convince the profession that the public wanted the best
obtainable, regardless of cost, and that it was economy to
give the public something better if possible. Now wide film
is going to get its just desserts and come into its own.
Wide film is not a panacea for all ills; in fact, it is not a
cure for any ills at all. It opens possibilities for bigger
and better pictures.

It is slightly more expensive, but the results justify
the increase. I believe that within a very short time the
public will be very emphatic in its discrimination between
wide film pictures and the old 35 mm. standard. This is
based upon conversation with people working with wide film
and they all admit after viewing wide film for a while that

*George Alfred Mitchell was the inventor of the famed Mitch-
ell Camera, first used by Charles Rosher in 1920 to photo-
graph Mary Pickford in The Love Light. In 1952, Mitchell
received an Academy Award "for the design and development
of the camera which bears his name and for his continued
and dominant presence in the field of cinematography."

George Alfred Mitchell (left) with Arthur Miller, veteran
cinematographer, photographed in 1969. Courtesy of
George J. Mitchell.

the 35 mm. standard looks funny. There is no need here to
go into the detail regarding the virtues of wide film. I be-
lieve that the industry is already sold on the proposition.

The question now before the industry is: How wide
should wide film be. Very little discussion takes place re-
garding the size and shape of perforations or the width of
sound track, it all centers around millimeters, 48-65-70--or
what is your idea.

Anyone of them is better than 35 mm. and almost in
proportion to their width. I believe every theatre should
show as wide a picture of their proscenium arch will permit.
Our lenses won't permit this with absolute sharpness in the
margins at the present time, but here is the point. Put
your principal action in the center of the screen and let the

margins go fuzzy if you please (we will have better lenses some day). It is much better to have your pictures fade off fuzzy on the side gradually than to stop the picture and restrict the view by a black border; concentrate your action near the center and the audience will not be aware that the margins are fuzzy. Look at twenty of the great masterpieces and note how much detail you can see near the margins of the canvas.

Now the larger your film is the less possibility there is of the grain becoming bothersome. A wide sound track is desirable for the ratio of grain size to slit width is reduced, therefore the ground noise is lessened.

The question of cost now comes up. Of course the wide film is going to cost more money, but not much more. Film as well as machinery will be more expensive. An important fact for the producer to remember is that the big cost on any production is labor. Don't forget that point.

Everyone knows that to design and develop any new process for any purpose is expensive. Often after a machine is designed and built the cost is only started for the changes necessary to develop the machine to practical perfection is problematical and often excessive. One way the studio can save lots of money is to adopt a process and machinery that is already developed and brought to a state of perfection to where it is commercial, and not try to develop some new system of width, pitch and perforation.

I do not believe that it is economically possible for two wide film systems to exist in the field and if various studios go ahead with several sizes of wide film I am sure the result will be a big loss to someone, which, in the last analysis, is a loss to the whole industry. No one likes to lose money and I don't believe anyone likes to see the other fellow lose money.

The system I advocate from an economical standpoint is called GRANDEUR*, and is available to the industry as a

*Grandeur, also known as Fox Grandeur, was first exhibited at the Gaiety Theatre, New York, on September 27, 1929, in

(cont. on next page)

whole and immediate delivery of cameras may be had. You
can get in production quicker with GRANDEUR than you can
build your own equipment to your own design. GRANDEUR
is proven and your own may give trouble. You can save
money for yourselves and the industry generally.

This system was developed at a tremendous cost, but
now that it is developed it is offered to the industry for
their use with no strings attached and with no royalties or
tributes to pay. The cost of this machinery will be lessened
as production can be increased and production can be in-
creased as, and in proportion to, the way the industry
adopts this system.

There is no engineering problem between 65 mm. and
70 mm. You can matt down to the 65 mm. size picture if
you use 70 mm. but not the reverse. Make the standard
adequate; 70 mm. is the logical and economical size it is
proven.

--Volume II, No. 3 (April 1930), pages 3 and 7.

the form of a scenic short on the Niagara Falls, a newsreel
and the feature, Fox Movietone Follies of 1929. It was also
used on Happy Days (1929) and The Big Trail (1930). In
advocating Grandeur, Mitchell neglects to mention that he
built the cameras utilized in the system and that his company
was at this time owned by William Fox, whose Fox Film Cor-
poration owned the Grandeur system.

AN ETERNAL TRIANGLE

by Virgil E. Miller*

A few years ago I wrote an article using the above title.
The article dealt with the cameraman, the director, and the
story. Today, with the multitudinous interests that the ad-
vent of sound has imposed upon the manufacturer of talking
pictures, I believe that a triad of the fundamentals can be
so chosen and correlated that the analogy to the triangle
still holds true.

An equilateral triangle is described as one having all
three sides and all three angles respectively equal. Any
divergence of line or angle will either shorten or lengthen
the sides with a corresponding change in angles; equality
will be replaced with inequalities; equal angles will become
either acute or obtuse, and the structure that symbolized
strength will have lost its greatest virtue.

A well-balanced talking picture must contain three
fundamental values, viz.: Story, Direction, and if I may
use the word, Presentation. That there must be a story is
axiomatic; it is equally self-evident that the story must be
told well and entertainingly; that is direction. Without good
photography and good sound, the efforts of both the author
and director are wasted.

*Virgil E. Miller (1886-1974) entered the film industry in
1913 with Universal, for whom he photographed The Phantom
of the Opera (1925). He published his autobiography,
Splinters from Hollywood Tripods (Exposition Press), in
1964 and the following year retired, after five years photo-
graphing the Groucho Marx television series. At the time
this article was written Miller was head of the Camera Depart-
ment at Paramount, where he photographed Dr. Jekyll and
Mr. Hyde (1932).

I am not particularly concerned with the story at this
time; suffice to say, as the story is weak, so also is the
whole picture structure--one leg of the triangle has departed
from the equilateral ideal. Neither am I particularly con-
cerned with the direction; a good story, poorly told, throws
a terrific strain on the other two legs of the triangle, and
we again have an unbalanced whole. But I am concerned
with the third value, Presentation, for Sound has become
co-ordinate with Sight, giving us at the present time the
third leg of the triangle, of such tremendous value and pos-
sibilities that its strength temporarily will support the adja-
cent weakened sides; eventually these sides will be built up
to meet the newly imposed conditions, giving us an equilat-
eral structure stronger than was ever builded by silent pic-
tures.

A mutual appeal to the ear and eye means a harmonious
blending of co-ordinated effort, and it is this phase of the
work of making sound pictures that interests the cameraman.
Prior to the introduction of sound, photography reached the
very ultimate of beauty; Corots, Rembrandts, Titians, Mil-
lets, and Raphaels flashed on the screen with the speed of
light, kaleidoscopically following each other in bewildering
array, either building up a weak story or bolstering up poor
direction until the audience forgot both story and direction;
or making a good story and fine direction stand out and
above the average because of the beauty of rendition on the
screen.

With the advent of sound, photography was forced to
give way to its "swaddling clothes" brother; this new play-
thing, appealing to one of the senses that had hitherto been
ignored, suddenly became an all-pervading force that brooked
no intervention; it rode rough-shod over built-up traditions,
and the poor cameraman played second fiddle to a new instru-
ment--the microphone.

With the coming of the "mike," and the accompanying
sound-track on the film, the cameraman's difficulties were
multiplied several fold: His composition had to be revised
to meet the new nearly square picture; he had to shoot
through an added piece of quarter-inch glass interposed to
lessen noise; he had to dodge microphones that further im-
paired his composition; he met with new lighting requirements
that had to be mastered; he was told to forget photography

in the interests of sound. With all these restrictions, and
with his being told where to place his camera and that he
must shoot under the conditions imposed by sound men--
many of whom had never seen a motion picture camera--he
was confronted with a dilemma that was trying, to say the
least.

After a year or more of sound work, it can be said
that the same determination that made the cameraman suc-
cessful as a silent artist has made him even more successful
as a cinematographer of sound pictures; he has overcome
most of the earlier difficulties that beset him, with the re-
sult that good photography is coming back. It has not yet
attained the perfection that it formerly had, but with the
laboratory co-operating to eliminate the Greek alphabet
(Gamma mostly), and a closer co-ordination existing between
the sound men and the cameramen, it won't be long until an
audience can once more revel in the beautiful renderings of
light and shade and color that is their due.

This article would mean nothing unless it carries a
helpful thought, and it is my impression that the greatest
reason for the improvement of sound photography lies with
the inherent qualities of the cameramen themselves in adapt-
ing themselves to changing conditions, and particularly to
their ability to work with and alongside the sound men who
operate the microphones. For a time there was a certain
amount of bitterness and jealousy existing between these
men, but in most cases the men themselves have learned the
futility of achieving results under such conditions, and are
working together, giving and taking, that their combined
or composite product may reach the high standard necessary
to keep the old box-office cash register ringing.

Such co-operation not only raises the standard of the
product itself, but increases the morale and lifts to a new
high level the qualities of the cameramen themselves; it
gives us a body of men who can take their place alongside
the men of those professions that make the world a better
place in which to live. Such co-operation strengthens the
third leg of the triangle, forcing the other two prime values,
story and direction, to meet the added strength if sound
pictures are to be equilaterally restored to a healthy condi-
tion that will endure.

--Volume II, No. 5 (June 1930), page 164.

SHOOTING ZEPPELIN A THRILLING JOB

by Elmer G. Dyer*

Photographing a giant air liner in action is quite an experience and accompanied by some thrills, too. When Columbia assigned me to this Dirigible** job I knew I had my hands full, and it would be something different from anything I had ever before undertaken.

When they told me the scenes would be taken at Lakehurst, I knew it would be still harder, since the atmosphere around this vicinity is not really ideal for air photography. The surrounding country is heavily covered with forests and underbrush, and there is nearly always a forest fire somewhere. In fact, smoke seems invariably to hang around this location.

It was quite a task to decide just which filter to use. Joe Walker, the chief, and I made numerous tests before the actual photographing of the scenes was begun. The next thing was to attach suitable camera mounts to this giant airship and arrange them in such places as to photograph the story action to advantage.

Joe picked three set-ups and I designed the mountings

*Elmer G. Dyer (1892-1970) entered the film industry in 1912, and soon became established as a leading aerial cinematographer, with his credits including Hell's Angels and The Dawn Patrol (both released in 1930). In 1947, he established one of the first independent stock footage libraries in Los Angeles.

**Released by Columbia in 1931, Dirigible was directed by Frank Capra, and starred Jack Holt and Fay Wray.

for the Zeppelin, one shooting back out of a window in the
rear of the control car, one in a side motor gondola shooting
out, and one in the rear motor gondola shooting forward.

It might be explained that a motor gondola is not such
an ideal place for a cameraman to work from, but since the
front of the gondola is the radiator it sure is a "hot" one.
With an enormous motor turning up 1200 r.p.m. the sound
is terrific. After a few hours of this one is nearly deaf
and half cooked.

The stunt being photographed was a small Vaught-
Cossar pursuit plane hooking on to the trapeze arrangement
attached to the bottom of the Zep. Many trials were made
before a successful one could be completed. We were about
four hours in all getting one hook-on, as the service men
call it.

New York at Night

At the same time Frank Capra, the director, wanted
a camera placed on the rear end of the fuselage of the plane
to catch a close-up of the pilot's action and the actual con-
tact. Here is a nice piece of business to watch.

It sure is a kick to see the pilot jockey his plane with
the finest accuracy, for one bad move might mean disaster,
but the navy fliers are good, they know their airplanes and
put on a real exhibition for the camera. We got the scenes,
and as I have heard since they were the best that ever have
been done.

I had a lot of wonderful experience on this production,
especially the two-day trip we made in the big Zep Los Ange-
les. The night we went over New York City was a great
treat for us. The ship took off in the dark for the big city
and we had no thought of being in the air. I just can't get
away from that sight.

Coney Island looked like a fairyland of glimmering dia-
monds, and the buildings looked different than I had ever
seen them before. They were all lighted up, it being the
time of night when the scrubwomen are all doing their tasks.
The buildings all appeared to be hollow and transparent like
great honeycombs.

Broadway at Seventh avenue with all its dazzle of
lights looked like a great Milky Way on the earth. We did
not attempt to shoot this, as the lights were too weak for
registration. We were waiting for daylight.

The coming of morning up there was some sight and a
great effect for the camera. The sun rose like a great crim-
son ball of fire over a vast sea of white billowy clouds cast-
ing its brilliant yellow and pink rays over a dead sea of cold
mist.

Shooting pictures in or from a dirigible is much easier
than from a plane. There is an extreme smoothness that
you do not have in a plane. There is no terrific wash to
cope with, the wind is broken, there is no whip or blast.
Going ninety miles an hour in a dirigible is like riding on a
cloud. One does not realize he is off the ground. It is
glorious flying in a man-made bird, and it is so steady to
shoot from.

I have shot air scenes from many kinds of air craft,
but this tops them all, and I hope everybody will some time
have a chance to ride in one.

Hunting a Set-Up

At Lakehurst we had some problems to work out be-
sides shooting from the Los Angeles dirigible. First we had
to get scenes of the Los Angeles itself and we needed a place
to stand. You know, we couldn't just walk over in the air
and pick a shot.

So the navy solved the problem. They gave us a
blimp for the camera ship, sort of a miniature edition of the
great Los Angeles, and you can handle them like nobody's
business.

It was quite a problem to mount the Akeley on the
gondola of this blimp, or "J" ship. We placed a plank two
feet wide and twelve feet long across the gondola. This was
chained fast to the forward end and furnished a nice spot
from which to shoot, giving free access to most all angles.
On this plank we screwed down the Akeley air camera.

These procedures took care of the camera--but just where the cameraman was to stand was something else again. So I just straddled the side of the gondola and rode it like a horse and strapped myself to the plank directly in back of the Akeley.

A "J" ship is powered with two 200 h.p. Hiso motors and flies at top speed about 70 miles per hour. We were able to keep fairly close to the zep and get many intimate shots.

We shot the dirigible over New York city, and there is where I had much grief with the light and smoke. Although the sun was shining, a terrible yellow pall hung over Manhattan Island. This, I understand, was caused from carbon and dust particles in the air from the factory chimneys on the Jersey side, and it just so happened the wind was in the right direction to carry it all over the city, nearly blocking out the background.

For these shots I employed heavy haze cutting filters, and yet the detail is not as I would like to see it. The Los Angeles was flying at an altitude of about 2000 feet, and this made all the more haze to cut.

Seven Hours in Air

I had to make a shot of the statue of Liberty and we descended to about 300 feet and circled around it. This was a kick, as we practically stopped for a few minutes while we took a shot. Since we had reduced our altitude, the photographic quality was much better, as there was much less haze to penetrate, and these shots came out very fine.

We returned late that day, having been in the air about seven hours. We overtook the Los Angeles above a very beautiful spot where the lakes and inlets reflect like mirrors. With a low sun the big cigar registered beautifully in the backlight and we landed just before darkness near the hangar at Lakehurst.

The next day was a real day for air shots. The weather had changed and the atmosphere was clean and snappy. Aided by a good wind the clouds were the cumulus kind that float about like big mountains of white snow.

We were assigned a navy plane to use for the camera ship--another Vaught. I mounted the camera on the scarf mount ordinarily used for the machine gun, and by adding several pieces it makes a very wonderful camera mount, since it can be moved from one position to another by releasing with a hand lever. Also the motor batteries can be carried in the baggage compartment.

The stunt plane was a navy Boeing pursuit ship piloted by a little flyer named Pee Wee O'Brien from the Anacosta naval air station at Washington, D.C., and I mean to tell you he's a real flyer.

We hopped off about ten o'clock, got about 9000 feet altitude, jockeyed into position, and then we went into a power dive, and this flyer certainly did some real flying-- upside down, tail spins, nose dives, loops, spirals and about everything else I can name and then some.

He did one of the most spectacular stunts I have ever shot. He came down in a dive and did a half loop and at the top spun straight up. This was a most unusual stunt. It's in the picture and gets a lot of comment.

Bouquet for Two Pilots

We spotted a beautiful cloud standing high like a frozen tower of snow. O'Brien flew right into this beautiful mass of mist and out the other side, giving an unusual effect. Then he would go flying into great shadowy canyons and out over big billowy golden crowned clouds. This was the background I had to shoot against, with a couple of sweet pilots to man the ships.

Last but not least is the great hangar where the giant dirigible Los Angeles and her three baby blimps rest. My first look at this place stopped me. Unless one has seen this great "Cathedral of the Air" he will have no idea what a massive piece of architecture it is.

Something around 750 feet feet long, 250 feet high and 300 feet wide, it houses all four of these ships and has room for some airplanes and other paraphernalia. My first impression was that it was not so big, but when I started to walk from one end to the other I soon found out otherwise.

Other members of our company made the same discovery, for shortly we were employing a light truck to transport our camera and props around. Then when I rode an elevator up about ten or twelve stories I knew it really was big. The view from the top level of the runways is a fine one and we made many interesting shots as the ships were being taken in and out.

Man chained for ages has broken his earthly bonds and soars to glorious new conquests. We saw the greatest array of both lighter and heavier than air craft ever assembled at any time. It presented one of the mighty spectacles against which the story Dirigible is staged.

This was done with the full cooperation of the United States Naval Air Service at Lakehurst. Thus was made possible the massing of large amounts of both types of aircraft, affording marvelous backgrounds. It was beautiful to see the dirigible Los Angeles in flight--and unforgettable.

Gliding peacefully and majestically over cloudbanks, drifting over some dream world vista and more fanciful than real, bound heavenward seeking new adventures, this wonder ship seems to represent man's glorious conquest of the furies and forces of nature.

Truly of such things mighty dreams are made.

--Volume III, No. 4 (May 1931), pages 4-5.

FIRST COAST PICTURE MADE IN 1906

by Earl Theisen*

It was inevitable that in the formation of the motion picture exhibit at the Los Angeles Museum there would be raised the query "When, where and by whom was the first motion picture produced in Southern California?"

Research to find the answer establishes the date as June 10, 1906, with the old Biograph Company getting the credit as producer, with A. H. Van Guysling and Otis M. Gove operating the machine. Californians will note with pride that it was California scenery and climate which made Biograph decide to open a west coast branch. All the details of this first attempt are given in a letter furnished the museum committee of the Society of Motion Picture Engineers on May 18 written by the then general manager of Biograph, George E. Van Guysling, which is quoted herewith:

"My attention has been drawn to the interesting collection of early motion picture devices and accessories being assembled in the Los Angeles Museum.

"In line with this effort I believe a statement relative to and establishing the date of the first movie production made in Southern California will be of value.

*Earl Theisen was an important name in the preservation of film history in Los Angeles. In the thirties, he created the "Movie Gallery" at the Los Angeles County Museum (later the Los Angeles County Museum of Natural History) and was the first to actively acquire film-related items for the Museum. He was also a prominent still photographer with Look magazine.

"My early work in scientific photography in the United States Government service abroad in 1889 and in various climatic conditions in our own country led me on my visit to Los Angeles in September, 1892, to recognize the unusual scenic beauty and favorable climatic advantages here offered, features of first importance in motion picture production.

No Talent Here

"The one great drawback advanced by those to whom I mentioned my idea was the apparent lack of talent. In New York we had ample supply momentarily to draw upon without incurring any maintaining expense aside from their salaries while engaged, but despite this advantage of making pictures in New York the weather was uncertain, with periods when successful out-of-door photography was impossible.

"With my election as executive vice president and general manager of the Biograph Company in New York City in 1904 came the opportunity to try out this long cherished ambition. I arranged to have my brother, A. H. Van Guysling, then residing here, to come east to familiarize himself with the business. Upon his return, associated with O. M. Gove, a photographer of ability, they opened a branch March 6, 1906, at 2623 West Pico street in Los Angeles under the corporation's name of the American Mutoscope and Biograph Company.

"The first moving picture they made here for general exhibition service was taken June 10, 1906, at Plummer's Ranch in Colegrove, Calif., at Santa Monica Blvd. and Vista Streets, in the present Hollywood. The occasion was the annual field day of the Vaquero Club, the members of which were noted for their daring and fancy exhibition of horsemanship.

"Members present included prominent men of the day and their ladies, including Dr. Fred C. Shurtleff, president of the club; Arthur Harper, Mayor of Los Angeles; Captain A. J. Bradish, Dr. G. A. Scroggs, Judge Pierce of the Township Court and E. R. Plummer.

Tally Plays a "Bit"

"The picture attracted great interest wherever shown,
especially in the eastern theaters. Later reels were made
up from sections of it for Mutoscope service in the penny
arcades. I enclose herewith six Mutoscope enlargements
made from this film.

"Shortly following this picture came the production ti-
tled A Daring Hold-Up in Southern California, started June
17, 1906, staged in Rubio Canyon, San Gabriel and Alham-
bra. Jack S. Hendrickson, noted California detective of
that day, played the leading role, assisted by Mrs. Jessie
A. Andrews. T. L. Tally and his son, Seymour, prominent
theater operators of Los Angeles at this time, took part in
this picture, which was directed and photographed by
Messrs. Gove and Van Guysling.

"Completed June 29, the negative was forwarded to
our New York office for a positive print, which was shown
in Tally's Broadway Theater here on July 10 and released to
the trade September 20, 1906, in Biograph Bulletin No. 82.
I hand you herewith one of these original bulletins, with
verifying dates and bearing the Los Angeles address of the
Biograph.

"Interesting moving pictures of the 'Ostrich Farm,'
'Pigeon Farm,' ascension of Mount Lowe and other local
events of interest were taken. The Los Angeles Chamber
of Commerce was a heavy buyer of these films.

"Many now living will recall the picture taken on Labor
Day, 1906, at old Exposition Park racing track and titled
The Locomotive Collision, staged by Messrs. Morley and
Hempel, the Biograph Company financing it. The event was
enlivened to a great extent by having one of the locomotives
bearing a large sign, almost enveloping its tender, reading
Examiner and the other Times. The smash-up was so com-
plete it was impossible to award honors to either of the news-
papers.

Biograph Remained Here

"The Biograph Company maintained a continuous

representation here, culminating in the erection of extensive
studios at Pico and Georgia streets in 1911. Many will recall
having seen these early pictures in theatres throughout the
country.

"In the event you desire more information regarding
this subject feel free to call upon me. Many of the persons
whose names I give as participating in these early pictures
are living and gladly will confirm my statements as here
given you."

Seymour Tally recalls the hold-up picture vividly.
And why not? He and Walter Duzan were the bandits so
relentlessly pursued by law and justice.

Corroborating the date, place and occasion for the
first motion picture, Dr. Fred C. Shurtleff, president of
the Vaquero Club at that time, remembers many interesting
incidents.

It is difficult today to grasp the doctor's statement
that no one took seriously the announcement made by E. R.
Plummer, vice president of the Vaquero Club, that a moving
picture was going to be taken. The photographic machine,
owned by George E. Van Guysling and Otis M. Gove and
mounted upon a spring wagon, was not overly impressive in
appearance, as it looked more like a trunk than a camera.

In fact, Mrs. Plummer remarked in Spanish: "That
man is not taking a moving picture with that coffee grinder,"
which gives a clear idea of how it looked to her, as well as
sounded. It is assumed part of the noise was due to the
film perforating mechanism in the camera.

Actors Shunned Camera

Dr. Shurtleff remembers distinctly he was riding a
bucking horse named Sultan at the time because he bucked
into the commissary department and started a keg of beer
rolling merrily on its way. No doubt the camera equipment
"set up" has been improved upon since that day, but what
about the contents of the keg?

Later by depositing a coin, looking through an eyepiece

as you turned a crank, any one could get a good picture of
"Sports at Plummer Ranch" in the "peep-show" machines
which enjoyed more popularity than the early motion picture
theaters.

The fact of the opening of this west coast branch at
223 West Pico street, Los Angeles, was announced in the
Billboard of June 2, 1906. Those interested in further in-
vestigation of the early pioneers here may go to the city
directories and find the Biograph listed in 1907 under the
name of Mutoscope and Biograph Company. It is so listed
each year. The next company to arrive, according to the
directories, was the Selig Polyscope at 1845 Allesandro
street in 1910, although Selig claims to have had a company
here in 1908.

It is interesting to note here that actors and actresses
of good standing lost caste with their associates if seen be-
fore the camera in 1906. It was the period of whiskers and
camouflage. Wallace Clendenin brings to light an interesting
incident of this era.

One eminent Shakespearean actor was prevailed upon
to appear before the camera. He always had been used to
plenty of territory in which to emote and found it difficult,
if not impossible, to confine his dramatic moments within the
limits of camera angles. Upon being told he could not travel
hither and yon he replied in disgust looking down his nose
with hand on chest and an arm akimbo on his hip in conform-
ance with the best form in dramatic gestures then in circula-
tion, "What care I for that contraption? All my days I've
done Shakespeare and never before have I required anything
like that there black box."

Such were the humble beginnings of an industry now
identified for all time with California and ranking as one of
the nation's greatest in size and importance.

--Volume IV, No. 6 (July 1932), pages 4-5.

TREK TO IOWA FOR REAL AUTHENTICITY

by Joseph A. Valentine*

We went to the animal fair--
The birds and the beasts were there--

Only we went to the Iowa State Fair, and not to watch the big baboon by the light of the moon put a wave in his auburn hair.

The trip was a regularly scheduled Fox production unit sent to Des Moines to secure background and atmosphere shots for Henry King's State Fair, the all-star special which boasts a cast of Will Rogers, Janet Gaynor, Phillips Holmes, Louise Dresser, Spencer Tracy, Sally Eilers,** one other star yet to be named, and Blue Boy, prize Hampshire boar which carried off blue ribbon honors at Des Moines.

Our party was headed by Director King, Blaine Walker, business manager, and included two camera crews, a sound outfit, with Bill Snyder as mixer; Ed Hammeras, special effects; Paul Mohn, assistant cameraman, and myself.

Like the Frakes, the family in Phil Stong's book, we arrived at the fair the night before the opening day and remained until it was over. The orders were to film everything the Frakes in the book saw and did at the fair, which meant that we had no time to lose.

*Joseph Valentine (1903-1949) became a director of photography in 1924. He photographed many of Deanna Durbin's films at Universal, and, in 1948, received an Academy Award for his work on Joan of Arc.

**When Fox released State Fair in 1933, Lew Ayres had replaced Phillips Holmes as leading man, and Spencer Tracy had been replaced by Victor Jory.

Joseph Valentine

In all, we shot 65,000 feet of Eastman new process background film. We were, I believe, the first to use this new stock on production. It gave us marvelous results, which pleased Mr. King and has drawn praise from all who have seen the film.

Getting Atmosphere

The sound equipment was one of the newly-installed Western Electric "Wide Range" units, which gave us no trouble or delays.

We covered the animal exhibits, the Midway, the races, general crowd scenes, and made intimate shots of the camp life of those who came to spend the whole week on the fair grounds, as the Frakes did in the book.

Particular attention was paid to the filming of the hog judging, the one weakness in Phil Stong's epic which critics have seen fit to pick on. We followed Blue Boy's career at the fair from his arrival to his final award of the blue ribbon as the Grand Champion Hampshire boar.

Mr. King afterward purchased the giant porker for the company, and he is now comfortably housed at Movietown City awaiting the start of the picture in which he is to be Will Rogers' entry in State Fair.

In addition we covered much of the rural section around Des Moines, filming the rolling hills, cornfields, villages, brooks, and general farm life, all of which is to be used in the picture. One running truck shot included the highway between Keosauqua and Des Moines, the route taken by the Frake family in their truck going to and from the fair.

Real State Pride

Mr. King, of course, wished to emphasize Iowa's tall corn, because of its symbolic relation to the rural life of that section. We found a field of the tallest corn I have ever seen and Mr. King became so enthused over it he wanted to drive right out in the field with the camera truck.

When we opened negotiations with the owner that individual just waved his hand and said go to it. We drove for over a hundred yards right out into the middle of the patch, knocking down three rows at a time with our heavy equipment.

But the farmer would not take a cent for the damage, claiming it was all for the sake of presenting Iowa at its best in the film.

We received unusual co-operation from everyone, especially the farmers whose land and stock we borrowed. They are very much interested that their locality is to be featured in a picture, and seemed not to be able to do enough for us.

In fact, the whole trip was a success, even including the hot dogs, with which we could feed the entire company at luncheon on a dollar and a quarter, an idea the business manager wished to continue. But we didn't mind. There must be a comedian with every outfit.

--Volume IV, No. 9 (October 1932), page 15.

EUROPEAN SUPREMACY?

Not long ago whenever motion pictures were talked about in
Europe the names of American companies were mentioned
loudly, also, very quietly, Ufa and Gaumont-British. Later
an agreement was reached between Ufa and G. B. to ex-
change stars with the help of British finance. This worked
out quite successfully until Herr Hitler came along and wiped
the Ufa and several other companies off the map. This left
a grand opening for G. B. She did not wait a minute--
while America was in the slump of depression and Europe on
the brink of war Gaumont-British quietly went on their way
building a gigantic studio, with five stages, at Lime Grove,
Shepherds Bush.

This studio was finished last June at a cost well over
$250,000. The studio is a striking tribute to the go-ahead
and far seeing policy adopted by Gaumont-British. There
are numerous offices for executives and clerical staffs, a
main theatre with accommodation for 250 people and also

*Although not among the cinematographers to whom attention
has been paid in recent years, Philip Tannura (1897-1973)
had a long and interesting career, which began when he
joined the Edison Company as a child actor in 1909. He went
to Siberia with the U.S. Army Signal Corps during the First
World War. From the early thirties through the Second
World War, Tannura worked in England, where his films in-
clude Counsel's Opinion (1933), Channel Crossing (1933),
Dirty Work (1934), Dinner at the Ritz (1937), Break the
News (1938), Stolen Life (1939), Inspector Hornleigh (1939),
and Poison Pen (1939). He ended his career photographing
the long-running television series starring George Burns and
Gracie Allen.

three smaller ones for daily rushes. Eleven modern cutting
rooms are a paradise for film editors with the laboratory in
the south wing. In the north wing are the carpenter shops,
electrical stores, camera shop, still lab and rehearsal rooms,
a canteen large enough to accommodate 200 people simultane-
ously, and a restaurant to handle an additional 300.

The stages have been equipped with up-to-date light-
ing apparatus on the style of Hollywood's best studios. The
biggest feature (which is a surprise that Hollywood has not
used) is the scaffolding for lights, platforms, and for every-
thing and anything conceivable to the mind. What a break
a cameraman gets for the handling of his lights on this
scaffolding.

Speaking of breaks--I must say that the employees of
Gaumont-British are getting theirs in the way of having
such marvelous executives at the head of the studio. In
the old days of motion picture producing in the United
States the heads used to take a personal interest in the do-
ings of their employees--the employees in return used to
work endless hours to give satisfaction in the hope of pro-
ducing an excellent picture--but alas, what has happened in
Hollywood--the same employees and executive heads are going
in different directions.

Not so with Gaumont-British. Mr. M. E. [Michael]
Balcon, in charge of production, is never too busy to see
every day's rushes--these from five different companies--
never too busy to go on the floor and give workers an en-
couraging word when the stuff is good--and when the stuff
is bad he doesn't fly off the handle as most Hollywood pro-
ducers do but gives the persons involved another encourag-
ing word in the most convincing and gentlemanly way and,
in return, each and every employee is breaking his back to
give service in a happy mood, all seriously hoping that every
picture made is better than the last. Such cooperation be-
tween the executives and employees is one main reason why
Gaumont-British has dominated the European market and also
making great strides towards the American market.

This company has stopped at nothing in getting tech-
nical experts behind the cameras. Three Hollywood camera
and lighting experts have been engaged and when these pic-
tures were reviewed it brought new criticism from the

scribes. One went so far as to mention:

> The best of our producers are following the Amer-
> icans hotfoot along the road to technical achieve-
> ment. Gaumont-British is the most striking case
> in point. This week we have seen two new Gau-
> mont films in London cinemas. Both these films
> set up new standards of technical excellence for
> this country. From the point of view of camera-
> work and lighting they are magnificent. We have
> every reason to be proud of them.

By way of news--Eddie Cronjager arrived and started
making tests for British and Dominion studios on the Mac-
Donald and Marshall picture. When all was set they found
out that time was too short for the production so had to be
cancelled. Eddie is talking about returning unless he signs
up with Columbia, that is if they pay the necessary do-re-
me. Bob Martin is making a picture for an Independent out-
fit on loan from A. R. P., starring Anna May Wong. Glen
MacWilliams just finished Murder Party [working title of un-
identified film] and is on a vacation to Germany. Charlie
Van Enger is getting ready to start another after getting
many raves over his last picture, I Was a Spy [1933]. Af-
ter resigning from London Films I signed up with Gaumont-
British and, at the present writing, am making a picture
called Channel Crossing [1933], starring Constance Cum-
mings. Bob LaPrelle is my operative cameraman with C.
Knowles. Les. Rowson returned with his summer tan from
down south and is making tests for his next picture.

--Volume V, No. 7 (August 1933), pages 17 and 41.

WONDERS OF INFRA RED*

by Elmer Dyer

For the first time we have taken Infra Red film above the clouds in motion picture work for motion picture producers. After making exhaustive tests and experiments with the film we had on hand, which was super-panchromatic, it was impossible to secure the results the director wanted and, until the time I had used Infra Red, we had not been able to get results that showed a moonlight effect. We got some very good night quality insofar as looking like night, but nothing like brilliant moonlight night.

The heads of the different departments at M-G-M were skeptical as to whether they should be able to let the sequence go through in the picture <u>Night Flight</u>.** After spending several hours with the director and getting his idea as to what really was wanted I was convinced that I could arrive at the effect in some way.

Having had experience with Infra Red in a picture I had worked on with Hoot Gibson, Harry Neumann, chief cameraman, I had a fair idea of what to do with the film and although I had not said anything about that type of film to anyone around the M-G-M lot I had it in mind in the event I ran into insurmountable difficulties with our regular film.

*Infra Red photography utilizes the infra red part of the spectrum. it was never widely used in the film industry except occasionally, for obtaining black-and-white effects from daylight shooting and in traveling matte shots.

**Released by M-G-M in 1933, <u>Night Flight</u> was directed by Clarence Brown, and starred John Barrymore, Clark Gable, and Helen Hayes.

When I first came upon the film it was introduced to me, as aforesaid, by Harry Neumann. He gave me a roll of it and handed me a filter which to me seemed practically opaque. I thought it was a gag and said: "You might as well give me a piece of burlap to shoot through."

I asked him if he wanted to get me kicked off the job. This produced several laughs, but I was told to put the filter on, pull everything wide open and shoot. The reader may imagine my embarrassment when I got into the projection room and saw the beautiful stuff I had made, for this film has surprising qualities for certain effects that cannot be obtained in any other way.

Great distances can be covered if the proper filters are applied and the proper exposure given. I do not claim to be an authority on this film, but my last experience has caused me to be very enthusiastic and as I go along in this business I am the more convinced that there is nothing impossible in the way of effects to be produced through the medium of film in a motion picture camera.

For many years I had tried to sell to some director or producer the idea of making a night sequence above the clouds. Everyone had always given me the same answer-- he did not think it could be put over--so when I came upon that M-G-M story and was told that the whole sequence rested upon the beauty of the photography, that it was straight flying and no stunting and that it had to be done to convey an idea of beauty in moonlight effect I told Mr. Clarence Brown, the director, that he was throwing something in my lap, as here was something I had wanted to do for years and that I was immensely pleased to get the break.

I must say that the co-operation I was given by the heads of various departments at M-G-M is certainly worthy of comment. I was accorded every possible support by all concerned. But knowing that the department heads were skeptical and that all eyes would be focused on the film I would bring back, rather than making me nervous it gave me an incentive to fulfill a long cherished ambition. Now, I don't mean to convey that this film is anything new or different or that I am the first one to use it, but I do mean that I have demonstrated a new angle on aerial photography which naturally will open up a greater field for beautiful scenes above the clouds.

In making these scenes I found out that I could get great distance. Some clouds were recorded by the camera that were easily 150 to 200 miles away from the scene we were actually photographing. Upon this occasion I was flying at an altitude of 10,000 feet, approximately, over Lake Elsinore, between Riverside and San Diego, which I roughly estimate to be a distance of about 55 miles.

Before making the scene I took a look at the background to be sure there was no earth showing, because we were supposed to be far above the clouds in the moonlight. There was no sign of earth and no holes in the clouds. All that was visible was a misty, hazy background. To our amazement when we finally ran this film the following evening in the projection room with the director and several department heads present, there was the bay between San Pedro, Wilmington, Long Beach and the Palos Verdes Hills--and they were very clear and distinct.

An Infra Red filter and Infra Red film had cut away the mist and haze and opened up an entirely new view for the eye of the camera.

Clouds have many fantastic forms; steady your plane, cruise around and find the artistic side of them. Nature paints her pictures up there the same as on Mother Earth and oftentimes you can obtain a beautiful scene so different it is fascinating. When the photographer starts cruising around up there he arrives at positions that are lacking in beauty, but suddenly he goes around the corner, as I express it, and comes upon a beautiful vista like a dream, it is so fantastic and weird.

Just recently, on a trip to San Diego, in looking for a spot to drop a parachute we came upon a place in the clouds resembling the Grand Canyon. There appeared to be a tremendous gash in the clouds, the center of which was very dark. The sides seemed to be like great clouds rising thousands of feet in the sky. It had the appearance of being worn away by some erosion--all caused by certain atmospheric conditions.

At other times I have seen grotesque figures formed in the clouds. I recall one time seeing a woman's face framed in a beautiful head-dress and as the sunlight fell upon it the face looked exactly like a white cameo against the blue sky.

All of these things are made photographically possible
by the use of the proper filter and films. I have brought
back to the earth from altitudes far below zero pictures
which, when viewed in the warm projection room, looked
like scenes from a warm beautiful sky.

Upon the start of this film in the night sequence the
question arose as to what color the plane should be painted.
After some discussion with Mr. John Arnold and Mr. Ollie
Marsh we decided to make a large testing chart. We painted
in five different monotone colors, ranging from white to
deep dead green and outside of that an aluminum strip. I
took this up on the top of a building and photographed
against the sky and landscape with seven or eight different
filters on super-panchromatic and also on the Infra Red.
This test was a very fine thing because we found there was
one color it was impossible to change with any filter we used
--that was the aluminum strip. From the lightest filters to
the deepest Infra Red filter the aluminum strip was always
visible, so we eliminated the possibility of losing our ship
at any time in shadows or in blue sky.

From that time it was only a matter of determining the
exposure and picking the shots and the locations. I was
greatly pleased when the company placed on me the respon-
sibility as the cameraman to choose locations for a big pro-
duction like Night Flight, also it was very fine that they
would send us by plane. The great saving in time was won-
derful. We left Hollywood about noon and were comfortably
settled in the hotel at Salt Lake City that evening. The
next day by noon we were sitting in the airport at Denver,
in the afternoon photographing a couple of thousand of feet
of film over the Continental Divide and Long's Peak; the
next day 2,000 or 3,000 feet more and on the fourth day we
had left Denver and were back at Los Angeles at five o'clock
that evening.

This article would not be complete without acknowledg-
ing my obligation to the scientists and producers of the won-
derful motion picture film we have today and the marvelous
lenses. Then too, a lot of credit goes to the pilots who fly
ships for motion picture work, for they go through as much
if not more than the cameraman. Some of them are mighty

clever and oftentimes are able to keep the cameraman's lens
on the objective plane in almost any kind of a stunt.

--Volume V, No. 6 (July 1933), pages 2 and 41.

MINIATURE EFFECT SHOTS

by Willis O'Brien*

In previous articles there has been so much misinformation presented relative to the methods used in obtaining effects shots (which do add immeasurably to the scope and general possibilities of the motion picture), that I believe a short description of the work as it is actually carried on might prove of interest.

The completed shot represents a combination of applied talents creating an ultimate picture or impression that, when well done is beautiful and conclusive. The dramatic value of the setting--its lighting and construction--are all necessary elements that must be studied and worked out prior to the consideration of the mechanical agencies to be applied.

A scene that flashes before your eyes on the screen for a few seconds may have required several weeks of concentrated preparation and work. Often a day's work of 25 feet of finished film is shown in about 1/3 of a minute on the screen. In the making of King Kong a detailed sketch was made for each set. The artist created a picture or illustration of that certain bit of action. This sketch would necessarily have to be complete in all detail--the comparative sizes of people and animals, their actions, the dramatic value of the setting and its lighting.

*Willis O'Brien (1886-1962) began his career as a special effects expert within the film industry in 1915. Aside from King Kong, he was also involved in The Lost World (1925), The Last Days of Pompeii (1935), Mighty Joe Young (1949), and others. He is the subject of an article by Don Shay in the Autumn 1973 issue of Focus on Film.

Each scene was planned as a single picture--a dramatic conception in black and white. Continuity sketches were made combining these larger sketches in their correct sequence, so that the protraction of the story would be kept, the whole, as well as details, receiving an infinite amount of study and research.

Then the best or necessary means to duplicate this conception was worked out. It might be a miniature set with the characters or people being projected into a part of it. The practical requirements necessary for the working of miniature animals might be necessary to consider. The advisability of using glass paintings, or, perhaps matting the lower part of the set so as to use conventionally photographed foreground must be taken into account. All these and many more possible requirements must be considered.

After deciding the means to be used, the layout or construction plans were drawn and detailed, even to the exact position of the camera and the placing of people and animals. This work is done by Carrol Shephird. If the people were to be projected or matted in the set, a complete drawing for that part of the set would be necessary, so that they would take their place in the miniature in the correct perspective and create a convincing picture. In many instances of a composite shot, a full size set with people would be shot a month or so before the miniature of which it would become a part, thus necessitating exacting layouts and camera setups.

The layouts are conceived entirely from the sketch so that the shot would be an exact reproduction of the artist's conception. Much research was necessary so as to obtain correct reproductions of every detail.

When the plans were ready the set or sets were put into work. Expert craftsmen carefully built the necessary units. It might be a combination miniature set with glass paintings and projected images, the sketch artists painting the glasses and backings themselves, and in many instances having the original sketch projected on the glass to serve as a guide for the glass artist. When the set is finished the cameraman and electrician light the set from the sketch.

Then tests were made until the required and desired

results were obtained, the final picture being a practical
setting and exact reproduction of the artist's conception.

From the foregoing it can easily be seen that the mini-
ature technician cannot bring his set to the screen single-
handed. It is fundamentally an artist's conception but re-
quires the united efforts of many craftsmen, its success de-
pending entirely upon the combination of artistic, photo-
graphic and mechanical effects, each person being a special-
ist in his field but also having a general knowledge of the
whole.

When making King Kong it was necessary to have a
large staff of experienced men to carry on the work. A
group of men were kept busy building and repairing the
animals or executing any mechanical necessity that was re-
quired. Another group built the miniatures, which included
a New York Elevated Railway recreated in detail and jungle
settings on a tropical island. Mario Larrinag and Byron
Crabbe made the sketches and later painted the backings
and glasses for the sets after the miniatures were drawn up
and put to work. Besides these men, others were necessary
for the actual working of the miniature.

Experience is the only teacher of the various treat-
ments required to obtain the desired effects. Each new set
is an individual problem and requires separate treatment.
There is no set rule or method by which you can classify
all miniatures. The scale and size must be individually de-
termined.

The miniature of today is a much more convincing and
effective medium than it was a few years ago. The intro-
duction of real people into the miniature (by process, matte
or projection) and the addition of sound have all helped con-
siderably. Many people pride themselves on being able to
tell a miniature shot on the screen. A well-executed minia-
ture cannot be detected, except by the expert himself.
Miniatures are very often shot at high speed, that is from
four to eight times normal speed. This is always done when
shooting water, as the scale and illusion cannot be brought
about except by the use of the high speed camera.

Miniatures and so-called trick shots are not a medium
used to fool the public, but rather a means of obtaining a

better or otherwise impossible angle to further the complete-
ness of the story and often is used as the only possible
solution to get the desired effect. The average picture has
a few. The Hollywood Herald called King Kong "the most
sensational exhibition of camera tricks in the history of mo-
tion pictures." It was probably the extreme case because
of its impossibility without them. New ideas and new com-
binations of older processes were used. Miniature animals,
combined with the projection of people on the miniature set,
created a scene that was convincing, not for the purpose of
fooling the picture-goer, but to give something new and
formerly impossible. I believe the public has come to realize
and appreciate the true creative ability required in the con-
ception and execution of these shots so as to obtain the max-
imum in artistic and realistic effects.

--Volume V, No. 4 (May 1933), pages 38-39.

BACKWARD, TURN BACKWARD

<div align="right">by Tony Gaudio*</div>

Dear Mr. Editor:--For some odd reason, oldtimers like my-
self get a great deal of joy out of recollections of the past.
The slightest incident on the set, a familiar face or scene
and the mind harks back to days gone by. The years roll
away as if by magic and on the silver screen of our mind's
eye is projected scenes which originally took place in the
long ago.

The other day I walked on the set of Silk Express,
which I was photographing at the First National Studios in
Burbank. One of the extra women said: "Good morning"
to me. I did not recognize her and so returned her greet-
ing quite casually.

"Don't you know me anymore, Tony," questioned the
woman wistfully. "I'm Florence Lawrence."

I spun on my heel and gazed more closely. It was
true. This was the original Biograph Girl, the most famous
glittering star of her time, the Ruth Chatterton of yester-
day! I had photographed her a score of times when she was
the pampered darling of her studio, with cars, maids, jewels,
fame. Now she was working as an extra on this set for $5
per day. Such indeed are the vagaries of fame, the irony
of life.

*Tony, or Gaetano Antonio, Gaudio (1885-1951) was active in
the film industry from the pre-teens through the late 1940s.
The most important of the films which he photographed are
those at Warner Bros. in the thirties, including Anthony
Adverse (1936), for which he won an Academy Award. This
article is of interest for its revelation that Gaudio wrote a
number of early films.

This incident started me thinking about the past.
Many happenings of those early days in motion pictures
came to my mind--the days of the Keystone Kops, of heavy
one and two reel melodrama, The Birth of a Nation and even
earlier D. W. Griffith masterpieces--much else. It occurs to
me some of these reminiscences are eminently worthy of re-
petition.

Take this story, for example: It was in the first
years of the industry--then really and truly an infant in-
dustry. The companies were all small, all struggling to get
on their feet. Leading actors of every studio were carpent-
ers, painters, set dressers and prop men as well as the
stars of their pictures.

Ralph Ince, John Adolphi and James Cruze, now di-
rectors, but in those days favorite leading men, would erect
the set, fix the drapes, set the furniture, then make up
their faces and enact the scenes. Florence Turner, the
famous Vitagraph Girl, simultaneously with her position as
reigning star of this company also held the positions of
wardrobe woman and cashier for the women extra talent.

Then Maurice Costello, New York stage matinee idol,
entered the lowly movies. Indignantly asserting his profes-
sion was acting, he refused point-blank to shift scenery or
erect back-drops. The other leading men followed his ex-
ample and also rebelled. The day was won and the producers
sorrowfully put through an order for carpenters, painters
and prop men.

A thousand memories of the old days crowd in upon
me, but most of these are grouped around the days when
Florence Turner reigned as the Vitagraph Girl and Florence
Lawrence as the Biograph Girl. In this same period, Mar-
garet Fisher was the Universal Girl, Pearl White was making
serials for Pathé such as The Clutching Hand, and others
with equally hair-rising titles. John Bunny was the chief
comedian at Vitagraph, Broncho Billy Anderson was making
Westerns at Essanay and James Cruze was the leading man
of the Thanhouser Company, in New Rochelle.

There were no expensive writing staffs in those early
days of the motion picture. I smile when I read in the pa-
per of some sixty writers being under contract to Metro-

Goldwyn-Mayer and stories of similar conditions existing at
the other studios, for in the early hey-day, directors, pro-
ducers, cameramen--even the office boy--suggested the story
which was filmed.

I myself wrote a goodly number of the scripts which I
photographed. Time has dimmed the memory of many of
these--indeed they were simply thought up, briefly outlined
and then "shot." Some of those from my own pen were
Conscience, a Vitagraph two-reeler starring Florence Turner;
The Queen's Honor, starring Mary Pickford and The Blind
Husband, featuring King Baggott and Owen Moore.

Henry Walthall was a "big shot" in pictures in those
days--young, handsome, adored. I photographed him in
Strongheart, in which Walthall played the handsome half-
breed football player. I recall going to Boston to photo-
graph the football game between Harvard and Yale for this
picture in which Blanche Sweet was featured. This was
about 1913.

I photographed Blanche Sweet in a number of pictures
--another was The House of Discord. Strange as it seems
Mickey Neilan was her leading man and Lionel Barrymore
played the heavy. The world knows of the later romance
of these first two. About this time Owen Moore and Mary
Pickford were one of filmdom's happiest couples.

In 1914 I was at the old Fort Lee studios in charge of
all cameramen. It was from here I was called to photograph
all the specials Biograph was making for Klaw and Erlanger.
Do you remember some of this famous series of pictures:
Classmates, The Woman in Black, The Millionaire Kid, The
House of Discord, etc.

In 1916 I came to California in charge of productions
co-starring Harold Lockwood and May Allison for the old
Metro Company. Then joined Norma Talmadge, all of whose
pictures I "shot" for four and a half years--Smilin' Thru,
The Lady, The Eternal Flame, others.

Reminiscences--a thousand of them come to mind. But
there is no room for all the meanderings which memory brings
to the fore. Enough to say that the good old days of motion
pictures were truly that--colorful, picturesque, memorable,

a time of preparation for glories to come. The mind caresses them fondly and then lays them away in its recesses to sleep until eternity.

--Volume V, No. 5 (April 1933), pages 18-19.

INTOLERANCE: THE SUN PLAY OF THE AGES

by Billy Bitzer*

Intolerance was made in Hollywood in 1915-'16 on Fine Arts lot, Sunset and Hollywood Boulevard, excepting the scenes taken of Cyrus' Army, which were taken at Nigger Slough, down toward Culver City.

Every bit of this photography was taken in sunlight, except the night fire scenes of the Babylon towers and walls. These were taken at dusk and with flares. No 24s, 36s, sun arcs or electric lights of any kind were used and, if you remember the picture, you can imagine the original figuring in the placing of sets, all of which had to be shot in sunlight.

An Amazing Dolly

One set, the Feast of Belshazzar in the Babylon period, was set three-eights of a mile long and, in this scene, was used an amazing dolly that even at this time (and I do not want to belittle our present day marvelous photography and angles) has never been equalled for its effects and smoothness of operation. This dolly was one hundred and forty

*Billy (G.W.) Bitzer (1874-1944) was associated with D. W. Griffith as his cinematographer from the commencement of the director's career in 1908 through 1929 (although, by all accounts, he did not actually photograph some of the later features for which he received credit). Bitzer had commenced his career with the American Mutoscope and Biograph Company in 1898. His posthumous autobiography, Billy Bitzer: His Story, was published by Farrar, Straus & Giroux in 1973.

feet high, about six feet square at the top and some sixty feet wide at the bottom. It was mounted upon six sets of four-wheel railroad car trucks and had an elevator in the center. It ran upon tracks starting away back taking in the full scene, or entire set, upon which there were five thousand extras.*

Walls 140 Feet High

This scene, or set, had walls one hundred and forty feet high all around it, upon which were huge elephants, many in number. Some of the walls were braced with telegraph poles and there were horses and chariots upon them.

Ishtar, a figure of the Goddess of Love, which looked puny in the full set, was thirty feet tall.

This great dolly was moved backward and forward by some twenty-five men, while another staff operated the elevator until from full set it ended in a close-up of large figures of the Prince and Princess seated at the throne, a pair of doves harnessed to a little golden chariot, carrying love missives between them, and the whole moving so smooth as to be delightful.

In fact, ten years later about this scene Richard Watts said in the New York Herald Tribune: "In this episode there occurs one of the most effective uses of the moving camera I have ever encountered--the scene where the camera moves slowly up the steps of the Babylon Palace." You see the effect was quite the reverse of the method in which it was photographed.

The "Intolerance" Way

In some of the pictures I see today, when I learn of the methods used, I wonder why, instead of the apparently roundabout way which looks so mechanical, they are not

*A sketch by Bitzer, accompanying this article, showed the "dolly" as being triangular in shape, but Karl Brown remembers it as being oblong.

D. W. Griffith filming <u>Intolerance</u> (1916); Karl Brown is
standing by himself on the left.

done in the simpler and more real and effective <u>Intolerance</u>
way. For instance in a scene showing apparently hundreds
of chariots (Cyrus' army) rushing to war, we simply hooked
our Cyrus' chariot to the side of our automobile, jiggled the
shafts up and down (no horses on that one) and rode like
hell in amongst all the other chariots. But more about this
sort of stuff later. While I am at it this same writer said,
when <u>Intolerance</u> was revived TEN YEARS LATER: "Here
is photoplay pageantry that for richness of fine composition
and general beauty is so impressive that it should make the
producers of the expensive <u>Ben Hur</u> to feel just a bit
ashamed of themselves."

How It Was Shot

This whole scene was made on only one hand cranked
Pathé camera. Karl Brown did the cranking, seated under-
neath the Pathé, through a flexible shaft, and I did the
handling of the tilt and pan cranks, looking directly through
the Pathé eye-piece focusing glass in the back door of the
Pathé on to the film, with a special eye-piece of rubber
which fitted around my eye to keep the light from fogging
the film.

The highest number of cameras used on the biggest
spectacular scenes of the different periods were never more
than four--all Pathés and, at no time in the ordinary scenes
made in this picture, which took one and one-half years to
photograph, was more than one camera used.

Karl Brown Enters

And right here I want to tell you about the wonderful
assistant I had in Karl Brown, who was more than an as-
sistant--an inspiration, a practical dreamer, as he later
proved in his works in the photographic continuity of light-
ing in The Covered Wagon [1923]; that most admirable
Tennessee mountain story, Stark Love [1927]--an intelli-
gent cameraman. Pleasant memories come to me as I recall
our working together. His constructive mind helped me
greatly in securing effects photographic in Intolerance.

There was one and one-quarter million (1,250,000)
feet of lumber used in Intolerance. The carpenters received
two and two and one-half dollars a day, worked each day
until finished--no overtime. Extras received five dollars a
day and, as I said before, no electricians were ever used.
We called the picture "THE SUN PLAY OF THE AGES."

A $15,000,000 Picture

I have calculated roughly, that at the present scale
of wages this picture would have cost over fifteen million
dollars ($15,000,000). We were assisted by some of the best
scientists in the world. Also in this picture made way back
there you see flame throwing machines, poison gas, etc.

You won't believe this, but it's there and, too, molten lead was used. Some of the moving fighting towers were as tall as the walls and were pushed toward the walls by elephants.

There were seven hundred and fifty (750) horses used; sixty (60) of the persons used became great; sixteen (16) became stars--and some who had the leading parts were never heard of in a big way again.

Costumes

In the four stories--The Babylon of Belshazzar; The France of Catherine de Medicis (French Huguenot period); The Jerusalem of Christ, and America before the World War, there were more than one thousand different kinds of costumes used.

When the fire throwing scenes were in full blast (fire being thrown from the moving fighting towers and from the walls) the neighbors living in little bungalows on streets adjoining the sets summoned the fire department and the big red ladder trucks and apparatus rushed past the gate guards into the scene upon which there were thousands of extras in action and spoiled nine or ten feet of film.

No Casualties

Remember we had only one camera running. Maybe Karl was grinding, too. I don't recall, despite the fact that one saw apparently hundreds of soldiers falling from one hundred and forty foot walls. In the closer views we used professional jumpers and nets. There were no casualties. We had an ambulance and corps of doctors and nurses, but only minor cuts and headaches happened. Intolerance had in it the whole of civilized history combined.

--Volume VI, No. 9 (October 1934), pages 24 and
27.

COVERED WAGON DAYS

by H. Lyman Broening*

Mr. Heinz may be credited with originating fifty-seven vari-
eties of pickles, but it remained for the pioneers of the mo-
tion picture business to devise an equal number of cinema-
tographic cameras, though to date all makes of film are pho-
tographed with one standard camera. Of all the varied types
of cameras of the days gone by, but one came into favor in
later years, and this one was the Bell & Howell, which was
developed by the Essanay Company.

Each of the so-called Patents Company** producing
units had constructed their own camera. There was the
cumbersome Biograph camera, a very ponderous contrivance,
with air pumps, perforators and all sorts of jim-cracks.
When it was set up for action it had the appearance of shoot-
ing sideways. The Vitagraph Company had its particular
camera, which focused from the front board by means of a
slanting tube alongside of the objective lens.

Failure to cap the tube meant certain disaster. Kalem,
Selig, Lubin and Essanay each developed a camera and to
the latter company may be credited the evolution of the Bell
& Howell. In fact, it remained to Messrs. Bell & Howell to

*H. Lyman Broening (1892-1983) was Mary Pickford's first
cinematographer. He entered the film industry in 1910,
photographed nine of Marguerite Clark's features, and was
the head of the camera department at Famous Players in the
teens. He retired in the thirties.

**The Motion Picture Patents Company was a consortium of
producers and distributors which tried to exert a monopolis-
tic control of the film industry. It was formed on September
9, 1908, and eventually disbanded in 1918.

bring the mechanical perfection of correct registration up
to its present standard. To these gentlemen we owed ab-
solutely steady pictures.

The independent companies were those not members of
the Patents Company and consequently not entitled to the
benefits of their mechanical patents. The Patents Company
owned and controlled about all of the vital necessities
towards the shooting of pictures, such as the intermittent
movement, loops, perforations and what have you.

As these could not be rented, leased or bought, it
created a most unfortunate and embarrassing condition for
the independents. These determined and struggling pro-
ducers, with limited capital, were forced into a sort of mo-
tion picture boot-legging business. As the Patents outfit
did not extend to Europe, cameras were imported from Eng-
land and France. The Moy, Williamson, Gaumont, DeBrie,
Prevost and Pathé were the popular makes employed.

A few German cameras found their way into the United
States, but were off standard as to pictures-per-crank turn
and were not generally used. The Patents Company, in
their effort to control the entire industry, by reason of their
extensive and complete title to patents, were in a continual
state of persecution of these struggling independent com-
panies.

During the "reign of terror" the cameraman came in
for his share of embarrassing moments and he had to be
somewhat of an artful dodger. None of the imported makes
of camera could be used in their original state, as the Pa-
tents Company officials knew exactly what was inside of
every model and a court injunction would soon put a stop
to their use, on a statute of infringement. As cameras were
the very existence of the "independents" life, only trusted
and loyal employees could be permitted to handle a camera.
No treasure was more carefully guarded and many cameramen
actually took their cameras to bed with them.

The art of camouflage was brought into use and me-
chanisms were encased in armor-plated boxes with the door
carefully padlocked. The camera could be loaded only by
the cameraman in a dark room, as the box could not be
opened where the prying eyes of some detective might peek

into it. A cameraman grew to suspect even his best friend,
and many of the actors were doubling as Patents Company
detectives. Location trips presented a problem. The film
was only two hundred feet in length. When this was shot
up it meant a trip back to the studio to reload. Then again
there was the ever-present buckling menace to help things
along. Outdoor work was, therefore, kept as near the studio
doors as possible. What fun!

The trusting cameraman was harassed on all sides;
bribed, threatened with jail and "gum-shooed" by detectives
at every crank turn, until artful dodging came foremost and
photography was secondary. One fatal peek by the enemy
and he had to substitute the camera he was using for some
other style or make. Switching cameras became a favorite
pastime, three or four different cameras being put into use
during a single day's shooting, just to keep the movies on
the move.

Most of the boys on the camera were loyal to their
employers, but there were instances of "selling out" or
turning traitor. Usually this was accomplished by the offer
of a better job or for a cash consideration. The writer was
made such an offer by a certain company when applying for
work in their studio. All that was needed to get the job
was to briefly sketch the movement of the camera used by
the last boss. A lapse of memory prevented me from getting
the job on such a basis.

Other menaces were ever-present to make the camera-
man's life miserable, such as static, scratches, bad perfora-
tions and poor negative stock. (Eastman film was not avail-
able to the independent pioneers.) Many feet of film and
much added expense was heaped upon the cost of production
in those days, due to mechanical variances, and retakes were
the order of the day. Patience and perseverance were cer-
tainly an attribute in those trying times, but with it all,
some very fine examples of photography were turned out.

Each cameraman had his own pet idea on how to over-
come the static bugaboo. Some resorted to bicycle lamps
under the camera, conveying heat to the inside mechanism.
Some relied upon chemical concoctions placed within the cam-
era on saturated sponges. Others insisted that a metal
crank handle would do the trick, by grounding the current

through the body. But with all these "sure cures" Old
John Static continued to play his pranks and many a beauti-
fully photographed scene was completely ruined with these
lightning flashes. Some of the camera outfits looked like a
Rube Goldberg cartoon, as many of our present cameramen
will remember.

Strange as it may seem, history has somewhat repeated
itself and the movie camera again finds itself enclosed within
a box, but for an entirely different purpose--to keep out
stray sounds, instead of stray peeks.

The intervention of the government and the untiring
efforts of Carl Laemmle and Adolph Zukor eventually broke
up the Patent Trust, resulting in a day of freedom for the
cameraman to operate unmolested. Bell & Howell created a
mechanical Eden and Eastman settled the raw stock difficul-
ties. Whether it be the hand of fate or not, every one of
the powerful Patents Company producing units passed out
of existence and the famous old trade-marks are just a mem-
ory.

--Volume VII, No. 6 (July 1935), page 29.

THE FUNCTION OF THE CAMERAMAN

by Curt Courant,* interviewed by Ernest Dyer

"In the first place," said Courant, "the word 'cameraman' is unfortunate. The suggestion it conveys is too limited, too technical. 'Chief artistic collaborator,' were the phrase not so clumsy, would be less misleading. The cameraman collaborates with the director and the scenic designer and others so as to produce an artistic picture. At the same time he is the captain of a team of specialists. On this film, for example"--we had just come off the sets of The Iron Duke**--"I am 'chief cameraman.' I have as assistants two 'first cameramen' and four 'assistant cameramen'--one first and one 'second' assistant to each camera. (We shoot everything through at least two cameras.) Then there are all the studio electricians.

"You ask me how far the cameraman is creative. Well, what does good camera-work imply? Is it just to secure a clear, clean, rich picture--a 'good photo' in the Kodak sense of the word? This is only the basis. No, good camerawork

*German-born Curt Courant was active in the German, French, Italian, and British film industries. It is somewhat ironic that Courant came to the United States in 1941 and could only work on films, Monsieur Verdoux (1947), for example, if the producer was willing to hire a union cameraman at the same salary. The publishers of this journal, IATSE Local 659, refused to permit Courant to join the union; this great cinematographer was told by Local 659 he could only enter the union as an apprentice and work his way up!

**Released by Gaumont-British in the United Kingdom in 1934 and the United States in 1935, The Iron Duke was directed by Victor Saville, and starred George Arliss and Gladys Cooper.

is to give to each scene the atmosphere which the scenario
of the particular film calls for. Each room, each set, each
exterior has to reflect the mood which is suggested by a
reading of the scene. If the mood of the scene is sad,
then the camerawork must be in harmony and must invest
the scene with just the right <u>ambience</u>. I read the scenario
like an actor and then try to interpret it in terms of atmos-
phere. Sometimes perhaps the result may not be 'good'
photography in the Kodak sense, but that does not matter
if it is the right camerawork artistically for that scene."

E.D.: "So we cannot evaluate any shot fairly apart
from its sequence. That seems to me well illustrated by
your own work in <u>Ces Messieurs de la Santé</u>* where the
lighting seems to change with the period, from the murky
gas gloom of the little shop to the electric radiance of the
modern store."

C.C.: "In those early scenes I wanted to make you
<u>feel</u> the dust. You do not want the screen always bright.
Think of the Paintings of Menzel and Rembrandt, so dark
that you have to go right up to them, yet perfect in mood.
We cameramen are after the same things as the old painters.
Instead of pigments and brushes we use lamps. We paint
with light. Instead of colors we have a scale in monochrome.
But what our cameras record is what our imaginations create
when we paint our sets with light."

E.D.: "To what extent do you control the sets them-
selves?"

C.C.: "That is a matter of collaboration with the de-
signer and director before shooting begins. We discuss the
sketches and models."

E.D.: "But that scene you have just been shooting,
with that broken gun-wheel you arranged so carefully upon
the mound, does your script give you the details of that?"

C.C.: "Oh, no. Such a scene can be arranged upon
the floor. Then I paint my sky-cloth with light to help the

*Unreleased in the United States, this 1933 feature was di-
rected by Pière Colombier, and starred Edwige Feuillère,
Raimu, and Pauline Carton.

composition. That big ball-room set you saw us shooting
the other day--every column of it has its roundness touched
off by some specially placed light, so that the scene had
form and depth and pictorial balance as well as the softness
appropriate to candle-illumination. The lighting made it a
composition."

E.D.: "What of the risk that shots with intrinsic pic-
torial appeal may detract from the thematic content of the
film? Robert Edmond Jones says that he is most content
with his stage settings when they fit a performance so per-
fectly that the audience does not notice them. Does that
apply to camerawork?"

C.C.: "The photography should enforce, not distract
from, the thematic content. Selfish photography is like
over-acting. The beauty of camerawork must be absolutely
lap-dissolved with the mood of the story. It is like some
vital part in the mechanism of a watch. The audience--
members of the average audience--should never be aware of
the camera.

"For instance, the camera's angle of vision is more
limited than that of the human eye, so that if we wish to
convey the impression of the unhampered movements and
gestures of George Arliss we have to follow him with pan
and track and keep him always 'trained' by a moving focus.
We must not allow him to be the prisoner of the frame. But
the audience is not aware of that constant movement. When
the audience feels that anything is technical then it is bad.
So with angles. The right angle is the natural angle. When
a technical trick is so good that the audience does not see
that a trick is being used then it is artistic camerawork.

"Look at that set in there. A sound-stage lumped
with 100 tons of dirt and turned into the battlefield of
Waterloo. Thirty electricians and 7,000 amps to light it.
An artificial sky within a few dozen feet of the foreground.
Yet the camera will give you a perfect illusion of miles of
depth. Shafts of sunlight touching the stone walls and the
branches of the tree. Every blade of grass almost with its
separate lighting. The impression of an exterior rendered
in the studio by artificial light!"

E.D.: "But why shoot it in a studio? Why not go
outside to begin with?"

C.C.: "Good! Consider the scene. It is the after-
noon of battle, between day and evening. There is a feel-
ing of hopelessness on the part of the French. Ney makes
his pathetic last stand. It calls for an atmosphere that is
mellow and _triste_. What odds on finding that lighting when
you wanted it in Nature! What hopes of _keeping_ it fixed,
if need be, for two days! Besides, there is the action to
be lit, too. That may want lighting different from the set.
Different players need different lighting. I do not light
Arliss as I light [Conrad] Veidt. We experimented and
found the quality of character lighting which would give
Arliss the rugged Wellington mask."

E.D.: "So that you would light Arliss differently in
two different films?"

C.C.: "Quite. A young girl on the other hand would
need soft lighting."

E.D.: "To what extent can you modify the script
once you are working upon it?"

C.C.: "The cameraman could always put a proposition
to the director. Saville, though, works very close to script."

E.D.: "To what extent are you limited on the floor?"

C.C.: "Only by time. I have to have my lamps
ready by the time the director is ready. Often perhaps I
could go on trying still better lighting. But you cannot
hold up a studio where hundreds of salaried players may
be waiting."

E.D.: "To what extent can you control the processing
or indulge in the tricks of delayed development and so on,
beloved by the amateur photographer?"

C.C.: "Developing is mechanical, automatic, entirely
uniform. The whole of a day's work, perhaps twenty set-
ups--will be developed together in one strip. And the
sound-track must have absolutely even development. (That
is only one of the limitations imposed by sound.)

"It means that the cameraman in the studio is respon-
sible for the balance of light and shade in the film shown on

the screen. Day after day, through some 1,500 different
set-ups, each with its slightly individual quality of lighting,
he has to maintain a general level of light. All the time he
has to have in mind the finished product on the screen.

"You ask how he is a creative artist. Consider. A
camera is a machine, a vehicle for the film; the lens is a
piece of dead glass; a lamp is a lamp; the film itself is a
chemical product; the projector is another machine, another
vehicle. The man who can visualize a scene in terms of
these dead things and from them create a work of living
beauty, he is a creative artist. That is my 'cry.'"

--Volume VII, No. 1 (February 1935), pages 16-17.

SIMPLIFYING COLOR LIGHTING

by William V. Skall*

As we simplify any photographic problem, we find ourselves able to think less about the mechanical routine of the task, and grow more conscious of the artistic and dramatic possibilities of our work. Lighting for natural-color cinematography should not be a problem; any color process must inevitably require more light than is usual in monochrome, but aside from this one requirement, the principal difference I see between the two is that in color you have far greater possibilities.

When assigned to photograph Pioneer Productions' Dancing Pirate**, I resolved to do everything possible to simplify the mechanics of the job, so that the possibilities offered by the Technicolor process and the story could be more fully realized. After reading the script which called for a great number of moonlight effects, it was felt that the mood called for softly pictorial low-key lightings. This in itself would build for simplicity; and by using light-colored sets, the problem would be made still more simple. So from

*William V. Skall (1898-1976) was a prominent Technicolor cameraman, with his credits including Northwest Passage (1940), Billy the Kid (1941), Reap the Wild Wind (1942), Life with Father (1947), and Joan of Arc (1948), for which he received an Academy Award. He also photographed the 1937 British Technicolor feature, Victoria the Great. Skall retired in 1965.

**Dancing Pirate was the second full, or three-color, Technicolor feature. It was directed by Lloyd Corrigan, featured Charles Collins, Frank Morgan, and Steffi Duna, and released by RKO in 1936. It was far from successful compared to Pioneer's first Technicolor feature, Becky Sharp.

the outset, it was planned to the use of light, neutral-tone
settings, and in the extensive preliminary tests Color De-
signer Robert Edmond Jones and I made, progressively re-
duced the key of the lighting for these moonlight scenes
until we were using what is, I believe as low a general level
of illumination yet tried in natural-color camerawork. The
results on the screen have so far been startlingly success-
ful. The color generally is more natural--restful rather
than aggressive; and as the lightings grew more simple, it
has been easier to balance the various angles of light to
avoid the colorless highlights and other unnatural effects
which have sometimes detracted from color scenes. In addi-
tion, the combination of lower keyed lighting and the light-
toned sets has proved a tremendous aid in the problems of
lighting some of the very big stage-built exteriors used for
the dance numbers.

But it is in the field of effect-lightings, I think, that
the combination of low-key lighting and light sets pays the
biggest dividends. Nearly half of the scenes call for night-
effect lightings, and thanks to the combination of light sets
and an improved dye-balance evolved by the Technicolor lab-
oratory, we have been able to reduce the light-level of the
night-effects to an incredibly low average.

Now there is more than one way of photographing
night-effects in color. Some of the cameramen favor the
use of more or less exaggerated cross-lightings, with a
rather general use of blue gelatine to suggest moonlight.
Personally, I haven't been able to visualize night scenes
made this way as being natural. Real moonlight gives a
soft lighting, mostly from overhead, with soft, luminous
and highly pictorial shadows. And it isn't aggressively
blue.

We have been able to duplicate this effect perfectly
by simply taking advantage of the natural color-differences
between the light-sources we have at hand. For our day
lightings, we use Mole-Richardson twin-arc broadsides and
overhead "scoops" for our general illumination; these units
are inherently balanced to give a strongly white beam,
closely comparably to sunlight. Our spotlighting is done
with the same firm's new "H-I-Arcs" and "Ultra-H-I-Arcs,"
and some of the older 36" SunArcs. All of these are high-
intensity arcs, and give a light which has just enough of a

faint bluish tinge so that for day effects we use light straw-colored gelatin screens to whiten the beam.

Using these high-intensity units without the gelatins --"raw," so to speak--we get a light which, in low-key effects, precisely duplicates the steely blue-gray of natural moonlight. So for our night effects, we light the set with unfiltered "H-I-Arcs" and Sun-Arcs, striving for the picturesque shadow-effects from foliage and balconies. The same units, of course, take care of modelling the players. As a fill-in light, to keep the shadows luminous, we use a few diffused "scoops" overhead, and a very few, well-diffused broadsides on the floor. Since the whiter light from these units is kept in a low key, and used simply to fill in the shadows partially, the difference in color is not noticeable, and is really an advantage. At times, our shot may call for an occasional trace of a more obviously bluish light here and there, to accentuate the moonlight illusion. This is done by simply slipping a blue gelatin onto one or two of the high-intensity units overhead, so that we get a few bluish catch-lights outlining the set or players.

Getting our moonlight effects this way simplifies the matter of getting the warmer tones of lamplight coming from within houses, or from street lamps. And again, we have a variety of effects available if we take advantage of the natural characteristics of mazda light-sources. Normal incandescent lamps will give a definitely warm yellow-orange light in Technicolor. The familiar reflector sunspots give the most strongly ruddy glow; the more efficient Mole-Richardson "Solarspots," while still warm-toned, give a far less ruddy effect. Playing these two familiar sources against each other and against the steely blue-gray of our arc-moonlight, we have almost every type of colored lighting needed for normal effects--and all without having recourse to the as yet barely explored (and therefore undependable) technique of using colored gelatins.

The range of effects is really surprising. For example, one of our tests showed a waist-length figure of a man in a flat Mexican hat standing in the moonlight. Under the hat, his face was in a deep but luminous shadow, while a strong beam of moonlight lit up the lower side of half his face. Two diffused M-R Side arcs took care of the front-lighting, filling in the shadow just perceptibly; a single

High Intensity arc spot on the lamprail overhead provided
the key high-light. You could hardly have lit the scene
more simply in black-and-white, though of course mono-
chrome would permit smaller units.

It should naturally be understood that what we have
been doing in this picture is by no means the idea of any
one individual, but the result of combining the thought and
experience of many experts in the fields of color-design,
art direction, illuminating engineering, and color-printing.
Our lighting technique has evolved in the natural progres-
sion of the many cameramen who have photographed Techni-
color during the past sixteen years. Since the 3-color
process has been in use, Technicolor's control system has
kept scientific record of every technical detail which gave
us invaluable information with which to work. Pioneer's
Color Designer, Robert Edmond Jones, and Technicolor's
Color Control staff, were responsible not only for the light
sets, but for determining exactly the right shade to give
the effects we needed.

Still another fortunate link in obtaining the present
results was the construction of the new Mole-Richardson
Type 90 and Type 170 High-Intensity H-I-Arc spots. These
new units have helped the color cameraman tremendously in
obtaining more pleasing and more effective lighting. They
allow a precision in lighting which could not be obtained with
earlier equipment.

Add to this a company which, like Pioneer, permits
time to get satisfactory light-effects, together with an Art
Director who contributes good costuming and set coloring,
and a constantly improved color process, and the result is
bound to show on the screen as an improvement--but it is
a combination of efforts on the part of many people and de-
partments.

 --Volume VIII, No. 1 (March 1936), pages 12, 24
 and 31.

CINELIGHTING THE STEEL MILLS

by Hal Mohr*

Lighting a set a quarter of a mile long is a problem in its own right. When you add to it all sorts of additional difficulties such as sooty black walls, the glare of molten steel, and a strict taboo against placing your lamps, cables or camera where they might interfere with the activities of a busy plant, you've raised the problem to really respectable dimensions. Finally, "top" the situation by allowing yourself a battery of only twenty-three relatively small lamps-- and you'll have as difficult a problem in lighting as anyone cares to side-step. Both your luck and your lamps must be more than ordinarily potent if you are to bring back anything!

That was one of the major problems I encountered a few weeks ago when the Universal Studio sent me on location in the plant of the Republic Steel Corporation in Cleveland, to bring back atmospheric scenes, backgrounds and Montage shots for a forthcoming picture. Many of our most important shots had to be made in the vast building that housed a battery of fourteen huge open-hearth steel furnaces.

The building itself was over 1,200 feet long. In the center were ranged the huge furnaces, with the wall of the

*An innovative cinematographer, who introduced the camera crane and was the first to extensively use dolly and boom shots, Hal Mohr (1894-1974) entered the film industry in 1915. His credits include The Third Degree (1927), The Jazz Singer (1927), Outward Bound (1930), A Midsummer Night's Dream (1935), The Phantom of the Opera (1945), Rancho Notorious (1952), The Member of the Wedding (1952), and The Wild One (1954). In 1934 he married actress Evelyn Venable.

building about 60 feet back from them. But there was pre-
cious little of that sixty-foot cable stretch between walls
and furnaces available for placing lights; it was a maze of
railroad trackage upon which moved an almost constant
stream of cars filled with ore, scrap-iron and molten metal,
while overhead great cranes juggled huge ladles carrying
hundreds of tons of liquid steel.

Common courtesy dictated that we should avoid as far
as possible doing anything to interfere with that stream,
especially since the mill officials cooperated so generously
with us. So the conventional method--bringing in a big
generator outfit, parallels, and several score bulky Sun
Arcs--was impossible. Our lighting system had to be cap-
able of working from whatever source of power the plant
supplied; it had to be compact and portable; and with all
that, it had to be extremely efficient not only in covering
a large area, but in penetrating power.

The answer was found in Mole-Richardson's "Cinelites,"
which were designed especially for location and industrial
photography. They are "Inkies," of course, but instead
of using ordinary globes, they use the No. 4 Photoflood,
which produces more light than a conventional 2,500-watt
Mazda. Since these globes are of the over-volted type,
their light is much whiter than the light of a conventional
Mazda, and consequently of much greater penetrating power.

The reflector of the "Cinelite" is a bowl-shaped alumi-
num spinning which throws a beautifully even light over a
spread of about 60 degrees. The globe fits in a socket
which is clipped over the edge of the bowl, and held in
place by a simple thumbscrew. Another thumb-screw holds
the socket assembly to the top of a conventional telescoping
pedestal. Finally, the three caster-equipped legs of the
pedestal may be removed by unscrewing a Tee handle in the
base.

By simply loosening these three screws, the entire
lamp may be knocked down in a minute or two. The bowl-
reflectors "nest"; the pedestals may be tied together like
so many lengths of metal tubing. Our 23 "Cinelites," com-
plete with cables, plugging-boxes, etc., were packed in two
ordinary trunks.

Hal Mohr

On the job, those 23 lamps were more than equal to
twice as many "Rifles." The lamps themselves proved, for
the work we were doing, quite as efficient as the average
"Rifle," while the whiter, more penetrative light of the
big "Photoflood" globes, in addition to having about two
and one-half times the intensity of the standard 1,000-watt
Mazdas generally used in "Rifles," was much better for our
purposes, as it carried farther, and had a higher actinic
value. Yet each of the globes, while considerably outdoing
an ordinary 2,500-watt unit, drew but a kilowatt!

In addition, the "Cinelites" were infinitely more port-
able than "Rifles"--and weighed less than half as much.

When we reached the steel mill we found that the only
suitable power line supplied D.C. at 240 volts. We brought
this down to a point where our lamps could handle it by the
simple trick of connecting the lamps in series, two-and-two.
In this connection I'd like to extend my compliments to the
electricians from Cleveland Local 27, I.A.T.S.E., who han-
dled our lamps. Competent stage electricians, this was their
first experience with motion picture electrical problems, and
for men suddenly thrust into intimate contact with a new
and highly specialized task, they acquitted themselves nobly.

We had a remarkably large crew. From Hollywood came
Production Manager Scotty Beal, Operative Stanley Cortez
and Assistant Ross Hoffman. In Cleveland, Irving Smith,
one of Universal Newsreel's aces, joined us to make Akeley
shots. Finally, in addition to our own electricians, the Mill
assigned to us a group of contact men, electricians and
laborers, which rounded out our crew to fifteen or more.

Generally, either Cortez or I operated the Mitchell,
while Smith ground away with his Akeley on action a studio
camera wasn't suited to getting; and often Cortez would busy
himself at candid cinematics with an Eyemo. When you add
to these three outfits the necessary magazine cases, battery
boxes, and the 23 lamps with their cables, globes and plug-
ging boxes it would seem as though we must have needed
a good-sized trunk to carry our equipment about. But
there are no roads other than railroad tracks in the square
mile of ground covered by the Mill. The "Cinelites'" knock-
down design solved that problem, however; we were able to
load our complete photographic and lighting outfit on an

ordinary railroad push-car which could be trundled around
by man-power, and lifted bodily from the track whenever
we stopped to make pictures, or when a trainload of ore or
pig-iron had to go by.

Until one has actually worked in a big steel mill, one
can have no conception of the vast scale on which the plant
and buildings are laid out.

When you try to light such a scene for cinematogra-
phy, you really begin to appreciate both the size and the
efficiency of modern lamps and film. The huge building is
normally as dark as night, with only the incandescent glare
from the furnaces and molten metal as an occasional, blind-
ing illumination. The walls and floor are covered--sometimes
inches deep--with a greasy black soot that simply swallows
your light.

On one side of the building--to the rear of the fur-
naces--the sand floor is honeycombed with molds into which
the glowing metal is poured to cool into ingots. In the roll-
ing mills a continuous ribbon of glowing steel passes through
a maze of machines which roll it into railroad rails, struc-
tural forms, and the like, finally shearing the tough metal
into relatively short lengths--twenty feet or so--like so
much dough.

It is manifestly impossible to build the lighting-level
up to anything remotely balanced with the glare of the
molten metal. And with the restrictions imposed on us by
the relatively few units we could use, the need for portabil-
ity, etc., I frankly did not expect a particularly high aver-
age of successful shots. That actually over four-fifths of
the 40,000 feet of film we exposed under these difficult
conditions proved usable is due, I believe, entirely to the
remarkable efficiency of the Mole-Richardson "Cinelites" we
used. Without these unique lamps I feel confident that not
one scene in ten would have been printable.

This demonstration convinced me that the "Cinelite"
is the ideal lamp for location use. Dan Clark's successful
use of them in photographing the Dionne Quintuplets is
another indication of their versatility, for there he had to
provide an ample exposure-level over a relatively large area
without injuring the babies' eyes. And their success on

such extraordinary locations should prove their value for
ordinary locations.

Using these compact, portable and efficient lighting
units for location lighting, for "booster" lighting, and even
for ordinary night exterior scenes, would simplify not only
lighting, but many other related problems. Smaller gener-
ators would be necessary; fewer and smaller trucks for
transportation; and the work could be done easier and
quicker than with heavy conventional equipment. Who, I
wonder, will be the first to throw overboard the traditions
of weight, bulk and amperage, and rely for location and
"booster" illumination on modern, lightweight, high-efficiency
units like these?

--Volume VIII, No. 8 (September 1936), pages 26-
27.

ARTIFICIAL SUNLIGHT SIMPLIFIES
TECHNICOLOR EXTERIORS

by William V. Skall

When we made Dancing Pirate, we filmed all of our exterior
scenes on a studio stage, where every factor of lighting
was completely under control. When we made Ramona,* it
was decided that virtually all of the scenes were to be filmed
on the natural, outdoor locations. None the less, the light-
ing must be as completely controllable as though we were
working on a stage. Modern dramatic cinematography de-
mands a high standard of portrait lighting no matter where
the scene is filmed; and when, as in Ramona, the produc-
tion is filmed in Technicolor, this is of additional import-
ance, for the relative newness of the color medium attracts
the attention of critics who otherwise take photography so
completely as a matter of course that they rarely mention
the cameraman.

In making Ramona we had two alternatives in lighting
our exteriors. First, of course, was the time-honored ex-
pedient of using reflectors to supplement natural sunlight.
Second, was the more modern method of using artificial
"booster" lights for the same purpose.

The first method had many disadvantages, and but
one possible advantage. Reflectors are much slower to use;
they must be readjusted constantly, to keep pace with the
changing angle of the sun; and they do not permit accurate
control of the reflected light. On the other hand, reflecting

*Released by 20th Century-Fox in 1936, Ramona was directed
by Henry King, and starred Loretta Young, Don Ameche,
Kent Taylor, and Pauline Frederick. It was the studio's
first Technicolor feature.

the sun's rays back into the picture from a silver or lead
reflector, one can be confident that the color of the direct
and the reflected light will be consistently the same--an un-
deniable advantage in natural-color photography.

Using artificial "booster" lighting, one has almost per-
fect control of the angle, spread and intensity of the light;
one is working with familiar tools, and can work as fast and
as surely as would be possible in the studio. But--the light
from your "boosters" must be a virtually perfect match for
the color of natural light, or the result on the screen will
not be natural.

Fortunately, this problem had been taken care of long
before Ramona went into production. From the start, the
Technicolor engineers have standardized their process with
the color-distribution of natural sunlight as the normal in
lighting. Following this lead, the Mole-Richardson engineers,
in designing the modern arc-lamps used in lighting all Tech-
nicolor pictures, have developed lamps which produce light
that is an almost perfect match for natural sunlight. The
"Side Arcs," which are used for general floodlighting pur-
poses, produce light that needs almost no modification to
double for sunlight. The high-intensity "H. I. Arc" and
"Ultra-H. I. Arc" spotlights, while their higher intensity
produces a slight excess of bluish radiation, need only a
very light straw-colored gelatin filter to make them match
both the "Side Arc" and the sun. And these newday spot-
lights, with their "Morinc-lens" optical systems, allow a far
more precise control of light than any previous units, for
they are free from both the element-shadows of the old
mirror-type Sun Arcs, and the dark centers and "hot cir-
cles" of ordinary reflecting spotlights.

Naturally, then, we decided that for all of the more
intimate scenes in Ramona we would use this man-made sun-
light for "booster" lighting. The results, I think, have
proven the wisdom of this course.

Only in the extreme long-shots did we use reflectors.
For all of the other scenes, we diffused the direct sunlight
with overhead scrims, and modeled the faces and forms of
the players with "H.I. Arcs," filling in the shadows with a
soft flood of light from the "Side Arcs." Almost always,
the scrim overhead was of at least double thickness;

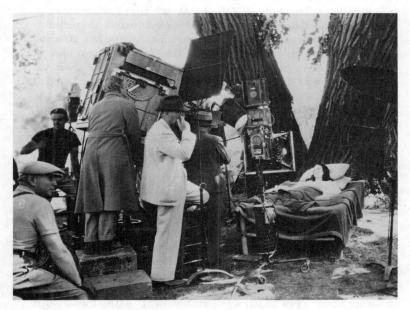

William V. Skall photographing <u>Ramona</u> (1936).

sometimes, even, we used a triple or quadruple layer of
netting. For the ordinary, intimate shots the scrims used
were of ordinary, small size. But on the larger shots we
used what is, I believe, the largest scrim ever flown on
location: two, and sometimes three thicknesses of the dark
neeting, and measuring 50x60 feet in size. Underneath,
we could work almost as freely as though we were on a
studio stage, and with vastly more precision--thanks to the
flexibility of the "H. I. Arcs"--than we could have hoped
to do with reflectors.

Occasionally we found it advisable to use reflectors
for an outlining back-light. In these shots, we had a real
chance to prove whether or not the lamp-designers had
been over-confident in saying their lamps matched the color
of sunlight. The general illumination of the shot was heav-
ily diffused natural sunlight. The back-lighting was strong,
reflected sunlight. The "fill-in" light came from "Side

Arcs," usually diffused with one or two silks. And the
modeling-light came from "H. I. Arcs" fitted with their
straw-colored filters. If any of these sources departed
from the chromatic standards of natural daylight, it would
certainly show up on the screen, for Technicolor, like most
color-processes, is sensitive to difference in the color of
light which would escape the eye. But on the screen,
nothing in these scenes reveals that some of the sunlight
was natural and some artificial.

As we made these scenes, we found another, rather
unexpected advantage to using arc-boosters. This was the
fact that the players found them easier on their eyes. Af-
ter all, it is far from easy to look natural while facing a
battery of blinding silvery reflectors. In Ramona we found
this especially noticeable, for the star, Loretta Young, has
eyes that are very sensitive to strong light, while the lead-
ing man, Don Ameche, was fresh from radio, and was totally
unaccustomed to keeping his eyes open in a strongly glaring
light. Both of them, I think, had been rather terrified by
the wild rumors they had heard of the strong lights needed
for color. Certainly it was a visible effort for both of them
to keep their eyes natural when we used reflectors. But
both of them were quite comfortable when we used the arcs.

Working outdoors, as we did, brought another problem
in lighting when one important sequence--that of a fiesta--
called for night-effect lightings on a large set. Working on
a stage, we could have done as we did in Dancing Pirate:
simply used a lower key of light, with the high-intensity
spotlights "raw"--that is, without the filters that corrected
their light to match daylight--and with here and there a lamp
or two fitted with a blue gelatin filter to give a hint of
moonlight blue in the backlighting. Obviously, we could not
do that under these circumstances. So we kept to our nor-
mal style of lighting with diffused sunlight and arcs, and
produced a slightly bluish cast overall by using a blue
filter on the lens of the camera. Where the warmer note of
lamplight or candle-light was required, it was produced by
using the over-volted "Movieflood" Mazda globes in Junior
and Senior "Solarspots."

In mentioning all these things which combined to make
Ramona what the critics have called a finer example of what
natural-color cinematography can be than were its predecessors,

the usually unheralded achievements of the Technicolor en-
gineers and laboratory experts must not be overlooked.
The Technicolor process of today is by no means what it
was a few years ago, when the three-color system was first
introduced. In those days the cameraman was severely re-
stricted in his lightings. Today he can shoot color with al-
most the same freedom he would black-and-white. Every
phase of the process has gained in flexibility.

With all these improvements the laboratory gives us,
not merely as good a print as the older requirements per-
mitted, but a much better print. For this, J. A. Ball,
Gerald Rackett, and the others in the research and proc-
essing plants deserve a world of credit. In fact, the real
heroes of this steady improvement between one Technicolor
release and the next are these men in the laboratory, and
the engineers who, like Peter Mole and Elmer Richardson,
give us better tools to use on the set. What these men do,
makes it possible for each Technicolor cameraman to do his
bit in proving to the world that not only is color a more
expressive medium than monochrome, but it is also one as
easily and efficiently worked, once its fundamental tech-
nique is learned. And as each Technicolor production is
released, it is better than those that went before. Ramona
is, I hope, a superior example of color-technique and color-
artistry than were its predecessors. The next color re-
lease, and the next, and the next, will undoubtedly sur-
pass it, just as it surpassed the others. So it will go until
the engineers, laboratorians and the cinematographers to-
gether have made perfect color more than a press-agent's
phrase, and color-filming itself as familiar--and as wide-
spread--as is today's black-and-white.

 --Volume VIII, No. 9 (October 1936), pages 14 and
 24.

COLORFILMING IN A BRITISH STUDIO

by Ray Rennahan*

The British studios are so widely scattered among London's sprawled-out suburbs that if you're on a picture in one studio, you have very little opportunity to get around to explore the others. So my remarks must be based on what I actually experienced while photographing Robert Kane's Technicolor production, Wings of the Morning, which Harold Schuster directed at Alexander Korda's remarkable new plant at Denham. But the American cameramen who have made pictures at the other studios in England agree with me that the outstanding feature of transatlantic picture-making is the genuine friendliness with which the British welcome reputable American technicians. Everyone--from the highest executive down to the gate-man--goes out of his way to cooperate with us, and to show his appreciation of our being there. It is the same in every studio.

British film-production actually dates back to prewar days, but the modern British film industry is relatively young. Being young, it has all the advantages and

*The Dean of Technicolor Photographers, Ray Rennahan (1898-1980) photographed the first two-color Technicolor feature, The Toll of the Sea (1922), the first three-color Technicolor live-action subject, La Cucaracha (1934), the first three-color feature, Becky Sharp (1935), and the first Technicolor film to be shot in the United Kingdom, Wings of the Morning (1937). A detailed account of the filming of the last is given by Anthony Slide in the February 1986 issue of American Cinematographer. British technicians responded to Rennahan's article in "An Open Letter to Ray Rennahan," published in the February-March 1937 issue of The Journal of the Association of Cine-Technicians.

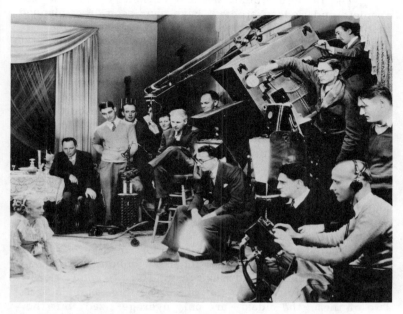

Ray Rennahan (seated to left of camera) photographing
Miriam Hopkins in <u>Becky Sharp</u> (1935); Rouben Mamoulian
is seated beneath the camera.

disadvantages of youth. Perhaps it has much to learn that
experience has made second nature to us; undoubtedly it
makes mistakes, even as we do in Hollywood; sometimes it
evidences growing-pains. But it has a vigorous, young
spirit that is a grand tonic: a determination to learn and
to succeed. It is the same youthful enthusiasm we old-
timers remember from the days when Hollywood was growing
from a sleepy village to the world's film metropolis.

In England, however, there is one tremendous differ-
ence: this youthful vigor has the latest and most modern
tools to work with. The newer British studios are quite
on a par with any in Hollywood; in some cases, their equip-
ment is even newer. England's greatest lack is in experi-
ence and trained technicians; but time will supply both, while
American help is undoubtedly speeding the process.

The Denham studio, where I worked, by far the most
complete and modern studio I have ever seen, was planned
and built by Jack Okey, well-known in Hollywood where he
was for years an Art Director at Warner Bros. Its location
is unique: an old estate bought from the once wealthy fam-
ily that had owned it for generations. In building the
studio, the beauty of the place has been kept intact. The
original house--a hunting lodge--houses the top executives.
The extensive stables have been remodeled into cutting
rooms, shops, and the like. The parked grounds of the
estate, through which flows the picturesque river Coine,
furnish exterior settings of unusual beauty.

Entering the estate, a curving drive brings you to
the main buildings of the studio. You can enter the ad-
ministration building through any of three large reception
halls, all of which are connected by a long corridor lined
with executives' and directors' offices. From the reception
rooms, roofed and glass-walled corridors lead across a gar-
den to the equally large dressing-room building, which also
houses Art, costume and make-up staffs. Beyond, more
covered pathways lead to the row of six big sound-stages.
Two of them--the oldest--are only average-sized; but the
other four are really big: they are at least as large as
Stage 5 on the United Artists lot here in Hollywood. At
the far end of this group of buildings, and reached by
more covered and glass-enclosed walks, is the studio com-
missary, with its cafe, bar, executive dining-rooms and the
like. If you have had any experience with England's show-
ery climate, you will appreciate those covered walks: once
in the studio, you can go through your whole day's activities
without having once to think about the weather!

Another convenience which would be of real value here
is the fact that near each stage is a separate lounging-room
for the extras. When you have a big crowd on your set,
it is very helpful to be able to send those not immediately
needed in the scene to this lounging-room, where they can
smoke and gossip to their hearts' content, and yet be in-
stantly available when needed.

On those six big stages, you will find an amazing
number of familiar faces. Quite aside from the many actors,
directors and writers from Hollywood working at Denham
while I was there, I found Johnny Boyle, Al Gilks, Jimmie

Howe, Phil Tannura, Lee Garmes and Roy Clark working on
adjoining stages. Bill Hornbeck, formerly Sennett's Chief
Cutter, is the mainstay of Denham's technical staff. Ned
Mann has charge of miniatures. And there are many more
Americans in the other studios. Incidentally, the only first
cameraman at Denham who was not an American was Georges
Perinal, the Frenchman who filmed The Private Life of Henry
VIII [1933] and Things to Come [1936].

This does not mean that there are no good English
cameramen. There are, though not enough as yet to meet
the needs of Britain's suddenly expanded production. But
as England has had to revamp its producing industry so
suddenly, the native cameramen have temporarily had to
take a back seat to the Americans, just as we once gave
precedence to cameramen from Paris, Rome and Berlin when
those cities were leaders in production. And just as our
native-born cameramen eventually proved themselves artists
equal to the best of any other country, so, too, we will
unquestionably find the British reestablishing themselves in
their own studios, working side by side with the world's
best.

On the set itself you will immediately see more familiar
"faces"--this time inanimate ones. The equipment used in
modern British studios is predominantly American. Britain
has developed little in this line, aside from Cooke lenses
which are as popular in Hollywood as in London. And of
course the Americans have asked for--and gotten--the equip-
ment to which they are accustomed. Our picture was shot
with a Technicolor camera that had seen service on most of
Hollywood's color productions; but while some of the Euro-
pean cinematographers favor the DeBrie, Eclair and Vinten
cameras, the majority of England's films are photographed
with American Mitchells, housed in Yankee blimps. The
color films are made with the four complete Technicolor out-
fits now in England. Most of the recording, too, is done
on the latest Western Electric and RCA recorders.

Another familiar "face" is the "M-R" monogram on the
lighting equipment. The Denham plant is completely
equipped with the very latest types of Mole-Richardson
lamps--18's, 24's, Rifles, Solarspot "Juniors" and all the
rest of the family down to baby spots. As we were shooting
Technicolor, our set was naturally rigged with Mole-Richardson

"H. I. Arcs," Side Arcs and scoops, exactly as though we
were in Hollywood. Denham has enough modern Mole-
Richardson equipment to take care of all the companies their
six stores accommodate at once, and arcs enough to meet
any demand a Technicolor unit might make.

Many of these lamps came from Hollywood, but while
I was over there a British Mole-Richardson factory was
started, under the guidance of another familiar face--Robert
Linderman. He began his firm's activities in England by
assembling Hollywood-made parts into complete lamps; but
now that the factory is organized, the lamps, with the ex-
ception of the essential "Morinc" lenses of the Solarspots
and H. I. Arcs, are completely British-built. It is interest-
ing to note the British custom of frequently giving a factory
a name, rather than an easily forgotten street number.
This particular plant is known as "H I Arc Works"--a name
not easily forgotten by anyone who has used these excellent
lamps.

Lighting itself is, of course, the same whether you do
it in Hollywood or in London. But the British studios have
one lighting problem that is unknown here. This is the
matter of power-supply. Even in the studios, the cost of
electricity is almost prohibitively expensive; so much so that
many of the studios have their own Diesel-electric generating
plants. Location power is even more of a problem, for there
is so much red-tape involved in getting permission to tap
one of the many high-tension lines that this is almost impos-
sible. Portable gas-electric generator sets are virtually un-
known. Mole-Richardson's British affiliate introduced a 300-
Amp. portable plant this summer, and it has been in such
constant demand that one of the firm's newest and 1200
ampere units is now on the way to help light the English
countryside.

The British climate is not particularly kind to location
companies. Between the proverbial fog and frequent show-
ers and thunderstorms, most of the studios prefer to avoid
locations wherever possible. Also, few property owners
permit their estates, etc., to be photographed. For the
same reason, "back lots" of standing sets and semi-
permanently built streets are almost unknown in England.
The weather ruins such sets too quickly: the sets built
only a year ago for The Ghost Goes West [1935] have been

so attacked by the weather that they are already virtually
useless. It would cost nearly as much to repair them as to
build completely new sets!

British interior sets are as well built as any you could
find in Hollywood. One set I noticed particularly, which
was built for a big musical film, was as fine a piece of de-
sign and construction as I have ever seen.

The chief weakness in the operation of the British
studios is that their minor technicians--property-men, elec-
tricians, and the like--have not had the years of production
experience that have taught their fellows in Hollywood the
importance of detail. For instance, you may establish a
certain prop in a sequence, and then move out of the set
for a day or so. When you come back to finish the se-
quence, your propertyman may have completely forgotten
that essential prop. If you're lucky, it will be merely mis-
laid; more often it is gone for good! "Grips" are virtually
unknown in England, the property-man does most of the
work done in America by our grip department. And the
props are very independent; if your property-man doesn't
feel well, he is quite likely not to come to work, and even
more likely to forget to say anyting about it to the studio!
After all, property-men are scarce, and he is sure of a job
at any other studio, so why should he worry? I can't
blame the fellows, for by American standards they are
badly underpaid, and I suppose that independence is about
their only compensation for it.

Incidentally, the cameraman in a British studio has
far heavier responsibilities than he has in Hollywood. Here,
we work with a perfected organization; in England, we work
virtually without it. Accordingly, the Director and the
Cameraman work doubly hard; many decisions which at home
would either automatically be taken care of by the production
department, or be handled by the assistant director, fall
upon the cameraman every day.

Here, we work with an electrical crew who know light-
ing, and who can be of great help to the cameraman in
preparing a set for his style of lighting. In England, the
electricians are eager and willing, but they have not had
the experience which teaches them the importance of placing
lamps correctly to an inch, and focusing spotlights to a

fraction of a turn. In England, you light your sets per-
sonally, rather than polishing a roughed-in lighting, as is
possible here.

Another problem is the fact that England is, in spite
of the many new studios and stages, cramped for stage-
space. When you finish with a set, it is struck immediately.
If you need it again, you must wait your turn for a stage,
and wait some more until the set is re-built, re-rigged, and
re-lit. During my picture, I had finished with one set ex-
cept for a single dolly-shot, which was all lit and ready to
go when dinner-time came. An hour's work and we'd have
been through. But it was dinner-time! The matter was
put up to the crew, who voted in favor of eating. We ate.
The set had to be struck so another company could use the
stage in the morning--and not until over a week later could
we make that one remaining dolly-shot!

From this, you can readily guess that working-hours
and especially night work are not what they are in Holly-
wood. Of course, if you have night scenes to make, your
company works at night; but otherwise (though some of the
American directors are trying to change the habit) British
troupes keep legitimate business-men's hours. And they
are definitely British business-men's hours--interrupted
promptly at ten in the morning and four in the afternoon
for that time-honored British institution, tea. Lunch is
called with clock-like regularity, too. But the amazing
thing is tea! Everyone on the set contributes to a tea
fund, and at the appointed hour,everything stops for fif-
teen minutes while the troupe drinks tea and nibbles cookies,
brought from the commissary by the property-man. Though
the idea seems surprising at first, you soon learn to ap-
preciate it, for it makes a very refreshing pause in the
day's grind. And after drinking the British version of
coffee, I can see why John Bull takes tea for breakfast!
I count as one of my more important achievements the fact
that, with Johnny Boyle and some of the others, I finally
persuaded the Denham commissary to serve real American
coffee!

But despite these distinctly minor faults, the British
studios are not only a very pleasant place in which to make
pictures, but a place where you can make good pictures.
It is amazing to see the fine new and completely equipped

British studios of today, and to realize that only a few years
ago their studios were small, badly equipped, and dedicated
only to the production of cheap "quota pictures"--films even
a poverty-row "quickie" producer would have been ashamed
of. The really representative British pictures of today are
such as any of our own major studios might be proud of.
It is true that the quota picture still exists, but it is im-
proving and vanishing. It is also true that no British
studio has yet developed the specialized production organi-
zation one finds in Hollywood's studios, but it took Holly-
wood many years to build up its own organization and not
even England's tremendous enthusiasm can build up such
an organization overnight. It will come; it is on its way.
Meantime, the cooperation between Hollywood and London,
as evidenced by the innumerable Hollywood-trained artists
and technicians now making British pictures, and the found-
ing of British branches by such firms as Mole-Richardson,
Technicolor, and others, is not only helping British films,
but cementing international ties that will be of lasting value
to both countries.

--Volume VIII, No. 11 (December 1936), pages 8,
13, 27-28, and 30.

CREATING LIGHT-EFFECTS IN TECHNICOLOR

by W. Howard Greene*

There should really be no mystery about effect-lightings in color. We have been doing effect-lightings in black-and-white for so many years that we have become quite accustomed to them; it takes something of extraordinary originality to awake more than passing interest. At present, color in its modern form is still sufficiently unusual to excite interest in details which, in monochrome camerawork, are part of everyone's daily routine. Actually, the whole subject of effect-lighting in color could be summed up with the statement that anything possible in black-and-white is equally possible --and a great deal more effective--in color.

One of the most significant facts about lighting Technicolor is that the cinematographers photographing Technicolor productions are progressively decreasing both the amount of light and the number of units needed to light any given shot. If you visited a Technicolor set of several years ago, when the three-color process was first being used, and then saw nothing of color photography or lighting until visiting a set where one of today's Technicolor productions is under way, you would be amazed at the simplification in lighting. There are fewer units in use everywhere. Fewer spotlighting units on the spot-rails overhead. Fewer floodlighting units on the floor. And except in extraordinarily large sets, the old overhead "scoops" have vanished.

*William Howard Greene (1895-1956) joined the Technicolor Corporation in 1917 and was still with the company when he died. He received two special Academy Awards, in 1936 and 1937, for his Technicolor work on The Garden of Allah (with Harold Rosson) and A Star Is Born. He also won an Academy Award in 1943 for the cinematography on Phantom of the Opera.

This is the result of a combination of many improving factors. For one thing, Technicolor's laboratory methods have been notably improved. The printing processes now permit the use of a much thinner negative than before. Modern Technicolor negative does not differ greatly from what any first-class black-and-white laboratory would pronounce a good negative.

For another thing, the lighting units which have been developed during the past year for Technicolor lighting are considerably more efficient than anything previously available. Viewed strictly as light sources, the new Mole-Richardson "H. I. Arc" and "Ultra H. I. Arc" spot-lighting units are immeasurably superior to the old Sun Arcs. Instead of casting an intense beam marred by a shadowed center, they project a powerful beam in which the light is distributed very uniformly. Thus it is not necessary to over-diffuse your light, and then use the overlapped beams of two or three lamps to build up to the required intensity. Another even more important improvement is in the color of the light these units radiate. Any color process, if it is to be used interchangeably on the stage and outdoors, requires an artificial light-source that gives light closely matching the color of daylight. The old Sun Arcs could not do this. Even with the most modern carbons, their light is too strongly blue. The new Mole-Richardson arcs, on the other hand, are infinitely better. The Side Arcs give an almost perfect match for daylight. The high-intensity "H. I. Arcs" need only the very lightest of straw-colored gelatin filters to do the same.

Lastly, and by no means least, is the fact that the Technicolor cinematographers are becoming more and more familiar with the possibilities of the process. Bear in mind that since Becky Sharp* was released less than two years ago, but five feature productions in Technicolor have been released. At this writing, two more have reached the preview stage, and an eighth is in production. Each of these productions has made us more familiar with the process. We are, I feel certain, much farther advanced relatively than we were in black-and-white when the eighth production was made on Panchromatic film in the far less revolutionary transition from Ortho to Pan. Due to the way the Technicolor

*The first full, or three-color, Technicolor feature.

engineers record all possible information, advances that any one cinematographer may make in Technicolor technique are available to all.

Thanks to all of these factors, Technicolor lighting has progressed to the point where on the average set, we use about the same number of light-sources that would be used to produce a comparable effect in black-and-white. We use arcs, it is true, rather than incandescents, and our units probably throw a somewhat more intense light; but several outstanding black-and-white cinematographers have stated that they would not be afraid to take their monochrome cameras on to a modern Technicolor set and stake their reputations on getting a thoroughly satisfactory black-and-white shot.

From all of this it can be seen that effect-lightings in modern color cannot differ fundamentally from their counterparts in black-and-white.

In one respect, however, there is a difference from the way many cinematographers approach a black-and-white lighting. Many of our most capable monochrome artists key their lighting essentially to their shadow-illumination, following the old adage to "expose for the shadows, and let the highlights take care of themselves." You cannot do this in color. There, the thing to be watched is the highlights. If they get too much light, the color is simply washed out and you have an unpleasant glare of white light on the screen. If, on the other hand, you build your lighting with a watchful eye on the highlights, and let the shadows graduate naturally down from them, your scene will be much more satisfactory. Incidentally, you will often find you can use a lower level of illumination if you light this way--and I think you can get your set lit quicker.

It is hard to specify a fixed ratio between highlight and shadow illumination. No one has yet done it for black-and-white, for each scene demands its own balance. But if one wants something mathematical upon which to hang his consideration of the matter, it might generally be said that in Technicolor it is a good policy to let normal shadows receive about one-third of the illumination the highlight side receives. From this one can graduate down the scale to midnight-black shadows ad lib.

In The Garden of Allah we had quite a wide variety
of effect-lightings, regarding some of which the critics have
commented most kindly. But I think that some of the most
outstanding lighting achievements in the picture have passed
unnoticed, even by the camera profession. For a variety
of reasons, it was deemed advisable to film many of our ap-
parently exterior close-ups on the stage. The peculiar style
of lighting best suited to our star, Marlene Dietrich, was
one important factor. So, too, was the climate of the Ari-
zona desert in summer! But it gave us the problem of pre-
cisely matching natural and artificial illumination.

Naturally, we made careful records of the direction
and intensity of the natural light. When we returned to the
studio, sky backings were prepared, carefully painted to
reproduce the exact color and gradation of the sky tones,
the cloud-formations, etc. Then we proceeded to make our
shots, using H. I. Arcs for the key-light, and Side Arcs
for the necessary fill-in light. The backings were illumin-
ated with Side Arcs and Scoops. The result was so perfect
as to be impossible of detection, even by those of us who
knew from having made the shots, which was which. Often
we would have these three lighting combinations intercut
within a few dozen feet; long-shots made with natural light,
and possibly reflectors; medium shots keyed with natural
light and H. I. Arc "boosters"; two-shots and close-ups
made in the studio, wholly by artificial light. Our only dif-
ficulties came on one or two occasions when for one reason
or another we tried to use the old-type Sun Arcs either for
"boosters" or for a strong key on the interiors; their light
was so obviously not the right color to match sunlight that
we had a great deal of trouble.

The picture also had several night-effect sequences.
In the past, two chief methods have been used in making
Technicolor night-effects: Using an overall blue filter, or
blue screens on the lamps (or both); and using the regular
H. I. Arcs without their regular straw-colored gelatins, with
perhaps an occasional blue-filtered lamp. In our night
scenes, we approached the problem differently. Working
either at night or on the stage, we kept our light to a very
low key. Then we kept most of our lighting normal--with
the straw gelatins--and here and there an unfiltered H. I.
Arc in the back-lighting, to give a little glint of steely moon-
light blue-gray. The result was extremely convincing.

For lamplight effects, of course, we used regular in-
candescent units--chiefly Mole-Richardson "Solarspots," usu-
ally with over-volted Photofloodtype globes.

From time to time there has been considerable discus-
sion of the value of projected color--the use of colored gela-
tin filters on lamps--as a means of widening the range of
color light-effects. To my mind, these effects have no place
in purely dramatic lighting. They can be spectacular, of
course; but they detract from the natural effect we are try-
ing to build in a dramatic film. In a musical revue, or even
in a night club dance routine, I would be only too ready to
use them. In a film like Frankenstein they would be useful
sometimes. But in a normal film, I feel that pictorialism and
mood can both be served best by an uncolored use of good
dramatic lighting such as we would expect in a fine black-
and-white production.

The matter of mood in lighting is even more important
in color than it is in black-and-white. Color is vastly more
revealing, not alone of the actors, but of the cinematograph-
er. It shows much more quickly whether or not the camera-
man is thoroughly in harmony with the mood of the action.
Just as some pictures permit a more extensive use of light-
effects in black-and-white than do other stories, so do cer-
tain pictures, if done in color, demand a more generous use
of effects than others permit. The Garden of Allah, for ex-
ample, called for lighting keyed to the mood of its action
and to its richly pictorial locale. My present assignment,
A Star Is Born, on the other hand, is a swift-moving modern
comedy-drama laid in a Hollywood studio setting. Extreme
effect-lightings would be out of place in this picture, even
as they would be were it done in black-and-white instead of
color; they would in either case slow the tempo, and be out
of tune with the light mood of the story. Such effect-
lightings as are used in this film must be done with a very
restrained touch--underplayed. For example, one sequence
recently completed is laid in a sunrise court room. The
room is drab. The action and characters are subdued. In
a more heavily dramatic picture it would be possible to in-
dulge in striking light-effects. In this case, the farthest I
can go toward effect-lighting is to keep my lighting severe,
though inconspicuous, with a fairly strong key-light coming
through a window, to represent the rising sun. The whole
scene, too, is lit in a much higher key than I would use for

the same setting in a heavier drama. In color, however,
there is a certain advantage in that the dull gray set,
photographed in color and lit drably, gives a much stronger
feeling of dull court room drabness than would be possible
in monochrome.

 And so I come right back to where I started: Sub-
stitute modern arcs for incandescents, and any light-effect
conceivable in the best black-and-white is equally possible
in color--and a great deal more effective.

 --Volume VIII, No. 12 (January 1937), pages 10-
 11 and 25.

EARLY STEPS IN THE HISTORY OF
MOTION PICTURE INDUSTRY

by G. W. (Billy) Bitzer

Any yarn about D. W. Griffith or The Birth of a Nation
[1915] or Intolerance [1916] must of necessity be news--for
it never grows old.

Now here are excerpts from a letter written some time
ago to the editor from G. W. (Billy) Bitzer, chief cinema-
tographer of Griffith's early works, those great land-marks
of the progress of the Motion Picture Industry--the early
records of its history.

The first part of Billy's letter was, of course, devoted
to personal matters and chatter about fellow-cameramen in
both New York and Hollywood, but soon Billy cut loose about
"D. W." and "D. W.'s" pictures in his own inimitable style
and it went something like that which follows:

The Magic Carpet

"Of all motion pictures ever produced, none were more
beset with difficulties than The Birth of a Nation and only
the belief and indomitable spirit of David Wark Griffith could
have carried it to a successful conclusion. Yet it is the one
picture that made money whenever and wherever it was
shown. What followed in its trail reads like pages from a
fairy tale.

"No other theatrical attraction has ever grossed an
amount anywhere near it. It is impossible to arrive at the
gross earnings for the theatres, but at any rate it is known
to be over eighteen million dollars. Every man who handled
the picture made not only money, but a big reputation. It

started Louis B. Mayer on a money-making career, William
H. Clune and many others. The cameraman was treated un-
usually well--I know he had two hundred and forty thousand
before the smoke cleared away, and while it was still clearing
away from those sand bag trenches and Sherman's March to
the Sea, evacuation scenes, etc. Now, do you believe I once
had a gold fountain pen. Mr. Griffith made over a million
dollars. The author, Thomas L. Dixon, who wanted $25,000
and something to say about the direction, got $25,000, no
direction say and a promise of earning percentage. What he
really received was ONE MILLION DOLLARS--the highest
price ever paid for any scenario.

"Everybody that had anything to do with the picture
was made happy. It was the great mortgage-lifter for many
theatres. Even today 'twenty years after' when the radio
is turned on in the evening for Amos 'n' Andy, the music
you hear for their opening was written especially for Mr.
Griffith, by Joseph Carl Breil, as the love theme number
for Lillian Gish. We called it 'Love's Sweetest Story.' It
was a beautiful thing when played by our orchestra. When-
ever I hear it now, no matter where I may be, a feeling of
great joy comes over me and thrills run up and down my
spine, even though it is not played as well as it was in the
good old days. Do you like that number? Yeah, it's pretty
nice. I never mention why--that's water under the bridge.
Still there must be something to it, when it's still played
every day after twenty years.

"The picture was road-showed and each show carried
its own complete orchestra, its own operators, sound effects,
sheet, in fact everything except the sour milk which they
used to whiten the sheet. If the theatre happened to have
its own projection machines, they were taken out and the first
time in pictures TWO PROJECTORS were used (our own), to
eliminate the 'Wait One Moment, Please' while the reel was
changed which had been in vogue up to that time. This also
eliminated unsteadiness, breakdown, undue flicker, etc. I
always think it was the first $2.00 picture, although of this
I am not sure. Many of the new blood would 'pooh! pooh!'
these facts set forth, because it's an old-school picture,
but they are true, nevertheless.

"The Birth of a Nation practically was made in our
studio backyard, Reliance-Majestic, corner of Sunset and

Hollywood Boulevards, excepting the battle scenes which
were taken on the old Universal Field, and a couple of cot-
ton field scenes, made at Calexico. The fir tree scenes
were made at Big Bear--and nothing anywhere else. Don't
forget, we were making 10¢ pictures for Reliance-Majestic
and were working on The Birth of a Nation when the New York
office wired, 'Finish picture at once. We will never get our
money back at ten cents.' That's the difficulty of making a
picture with no dough. The getting of this money is a tale
in itself, but happily everyone that put faith and money in
this picture were repaid many, many times over. Goldstein,
a Los Angeles costumer, furnished the uniforms for an in-
terest. Bill Clune, the theatre owner, put in S.O.S. to have
first run. Actors and extras were paid, however, and this
picture made most of them famous--Wally [Henry B.] Walth-
all, the little colonel, Mae Marsh, Wally Reid, and many oth-
ers. Of course, that isn't so unusual today, but these
were a lot of little people of whom no one had ever heard.
One of the difficulties was that the picture was a departure
from the given path in its treatment. It ran the whole
gamut of emotions--Love, Battle, Run to the Rescue; no
matter what you liked in a picture it was there. And when
D. W. Griffith put it there IT MOVED!

 "I started writing with the Magic Carpet in mind, a
carpet in the old Alexandria Hotel lobby upon which, if one
had any thirty thousand dollar picture schemes, they would
step away from the cheap talk at the adjoining bar and on
to this carpet. It's a story in itself, how so many of these
dreams they didn't believe themselves became actualities.
Yet, Charlie Chaplin, mooching drinks when Lloyd Winnie
Sheehan, Chuck Reisner, or anyone else would buy, already
had his first $1,000,000 film contract. The first payment
was to be $670,000, but he wouldn't go ahead until he re-
ceived a wire from the Chicago bank that the dough was
deposited to his account. This is just one of the true
Magic Carpet tales. But to get back, up to this time, on
these little schemes, much over $30,000 never was talked
of. When the fabulous earnings of The Birth of a Nation
began to become known, sixty grand, eighty and ninety
grand was on the line. The reason I am citing all this is
because they all thought they could make a picture along
similar lines and have a hit.

 "Thomas Dixon, at the Ambassador Bar, once showed

me his weekly check and said to me: 'I'll bet my check
this week is bigger than yours.' Of course, it was. He
started right in to make a picture better than The Birth of
a Nation. He called it The Fall of a Nation [1916]. He was
so sure that it would be a great success that I can remember
a large sign on a conspicuous building in Times Square, New
York--many, many months after the picture was forgotten.
I suspect he was sure that it would have at least a year's
run and had taken a long lease on the space.

 "Goldstein, the then Los Angeles costumer, made a
picture. Instead of the Blue and the Grey, it was Britain
and the United States, something about the Boston Tea Par-
ty.* J. J. McCarthy, who handled the bookings for The
Birth made a picture, The Betrayal [possibly Betrayed,
1917]. They all flopped, and I'll tell you why. D. W.
Griffith, after battling for dough, battling for the right to
make his way; the tremendous zeal, energy and genius he
put into having its timing just so, its tempo right to a hair,
worked in the day and then far into the night. He is a
wonderful man, this gentleman from Kentucky. I'll never
forget what he said to me in the lobby of the Astor Hotel
when he wanted me to quit the then Biograph Company,
'Come with me, Billy; we'll work like h... for a few years
and make a million dollars.' He made a million. I made
enough. I could have made more.

 "From all this you will gather that our then family,
who were fattening on their tremendous profits, started at
once to try and make a better picture than The Birth of a
Nation. Most everyone took credit for its success, theatre
owners, roadshow men, publicity men--but it's the same to-
day, you can boost a picture to the skies and they 'no
come.' If it's got what it takes, lines form on the right.

 "Two Chicago promoters tried to capitalize on The
Birth of a Nation by selling stock to certain racial groups
of the nation on a production to be entitled The Birth of a
Race [1919], a super-special. They had statistics of the
financial success of The Birth of a Nation and promised

*For more information on Robert Goldstein's The Spirit of
'76 (1917), see Anthony Slide's article in the January 1976
issue of Films in Review.

glamorous prospects for The Birth of a Race. Strong arm-
men went through Chicago and other mid-west cities. In
about two months they had landed $1,500,000 cash from one
group. Then they thought: 'Why not sell the idea to the
negro population?' They collected another $1,000,000 from
the colored folk down south and midwest. These people had
no story to tell, so they took something from the Bible and
decided to make the picture in Florida and use the colored
folks for extras. It was made in Tampa in 1918.

"They had a special boat from New York loaded with
three hundred actors. In two months the picture was
shipped to Chicago, where the producers leased the Black-
stone Theatre. It lasted four weeks--long enough for all
the passes to come in from stockholders throughout the coun-
try who had come to see the picture that would make them
rich. Box office showed several hundred dollars cash. It
has never been shown publicly anywhere since."

--Volume VIII, No. 12 (January 1937), pages 22-23.

RENNAHAN TALKS TECHNICOLOR

by Ray Rennahan

All that is needed to strip the so-called mystery from color camerawork is to consider it from the same practical viewpoint we ordinarily use in discussing black-and-white. Not so long ago every detail of our routine black-and-white camerawork was at one time shrouded in mystery; today, experience has made them accustomed commonplace. And that same experience applied to color will make it commonplace, too. There are many little ways in which we can make any kind of camerawork easier or more effective by simply sidestepping the difficult or impossible things.

Color can be approached in the same way. If the cameraman will keep alert, he can discover many little practical tricks, which not only make his color scenes better, but also enable him to accomplish them more easily.

Modern Technicolor is photographed under arc lighting. This in itself should be no difficulty to the competent cameraman. Nine years ago the industry took without faltering a sudden change from arc to incandescent lighting. In turning to color, the reverse of this transition should be easy.

The chief reason for Technicolor's use of arc lighting is in the fact that any color process must take into consideration not alone the intensity, divergence and diffusion of its lighting, but also the color of the light used. If the light varies appreciably from the colorless white standards of natural daylight, that variation will be reproduced on the screen. The arc lamp is inherently closer to that standard than any other type that can be used for pictures. A program of extensive research, carried on jointly by the Technicolor staff, the National Carbon Company and Mole-Richardson,

Ray Rennahan

Inc., has given us arc lighting units whose light is an al-
most perfect match for natural light. The low intensity
"Side Arc" floodlighting units produce light that needs no
correction to match this standard. The high intensity "H. I.
Arc" spotlighting units, since high-intensity arcs produce
an inherently more bluish ray, require a very light straw-
colored filted to match this daylight standard.

This brings us to one of the first points the color-
cameraman must watch. Occasionally the best of electricians
will accidentally leave the correcting filter off one of his
lamps. Unless the cameraman has schooled himself to be as
conscious of the color of light as he is of intensity and dif-
fusion, the omission may escape attention until the rushes
are screened. Then it shows up as a distinctly bluish beam
striking unnaturally onto set or player. It requires only
a little practice, however, to be able to glance at a set and
notice this all but invisible flect of steely blue; I have been
repeatedly amazed how quickly cameramen and gaffers pre-
viously unaccustomed to color have learned to note such de-
tails. Soon they do it almost subconsciously.

The matter of lighting level has been argued too often
both in and out of print. Each cameraman balances his light-
ing differently, and determines his own favorite lighting
level. Just as in black-and-white it is impossible to say
that one man is right and the other wrong, because they
use different light levels to secure comparable effects, so
it is impossible to say how much or how little light must be
used from any one source on a color shot. Successive ad-
vances in both emulsions and laboratory technique have
brought Technicolor lighting requirements progressively clos-
er and closer to parity with comparable monochrome.

In this phase, too, we are aided by the fact that, unit
for unit, the "H. I. Arc" spotlighting units used for color
are considerably more efficient than most of the lamps used
for black-and-white. They throw smoother, more control-
lable beams; they are, in fact, arc versions of the familiar
incandescent "Solarspots." Unit for unit, the modern Tech-
nicolor set uses no more light-sources than would be neces-
sary for black-and-white; in some cases, thanks to the more
efficient light-distribution of our lamps, we can use fewer
sources.

The fallacy that color must be lit flatly has now been pretty well exploded. Some of the flatness in the early three-color pictures was due to the early limitations of higher light levels and to the fact that in those days the present modern lamps were not available.

In actual fact, Technicolor scenes can be lit with much the same range of flatness or brilliance that would be desirable for the same scene in monochrome. In so far as my personal preferences go, I prefer to light Technicolor scenes with a bit more contrast than I would use in black-and-white.

A great deal of the contrast as well as the intensity of lighting required for color scenes can be governed by the cameraman's choice of set-ups. This is noticeable in black-and-white, but it is still more evident in color. Often moving the camera a scant few feet one way or the other can make a tremendous difference in the lighting required, saving both time and current in notable amounts.

In black-and-white the cameraman, after a brief outline of the nature of a shot, can often very safely leave the details of camera set-up to his operative crew while he concentrates on lighting. In color, this is not the case. This is not said with any sense of slighting the abilities of the operatives, but simply because the combination of color with line, mass and lighting requires more precise planning than do the three latter factors alone.

My personal method is to plan the set-up very precisely by inspection through a detached finder, thereafter indicating to my crew the exact position of the camera to get the desired composition--the camera's position, its height from the floor, the exact angle, and so on.

In a color film, the background as a rule plays a much more important part than it does in black-and-white. An area of some strong color here, another one rendered too vividly there, can upset an otherwise very effective composition. This fact is something the cameraman coming newly into color from black-and-white must learn to consider in detail. Ordinarily, such a splash of color might, in black-and-white, be rendered as an inconspicuous neutral gray. In color, it would be rendered as color--possibly as objectionable color.

This planning requires careful cooperation from the director. If he will really cooperate with the cameraman and understand his problems, he can often move his action, and with it the camera angle just that little bit to one side, or closer to the wall, farther out, etc., and thus do much to greatly simplify this problem of color composition enormously.

I have found it very helpful to plan my background (or set) compositions first, quite independent of the principals, and then to fit the players into the compositional pattern, rather than to strive to coordinate two otherwise conflicting units at once.

Closely related to this is the matter of set dressing. In monochrome, an over-dressed set is not often noticeable. In color it will be. Actually, the simpler a color set is dressed, the more effective will be the picture on the screen. Genuine cooperation between cameraman, set-dresser and art director both before and during shooting is doubly necessary. Color adds so much to a scene that physical simplification is vital. Elimination of surplus detail actually builds to a stronger and more pictorial scene.

Practically all of these details, it will be seen, have a parallel in black-and-white camerawork. Every black-and-white cameraman is accustomed to watching them almost subconsciously in his daily work. The only difference is that in color they must be watched more closely and (at least at first) more consciously.

Once these details and the somewhat narrower latitude of any color process are understood, any able black-and-white cameraman can photograph color as easily and as confidently as he does black-and-white. This is proven by the increasing number of major studio Technicolor productions being photographed by the studios' own black-and-white cinematographers with but a bare minimum of coaching--advice, rather than help--from Technicolor cameramen. This trend is bound to continue; and as it does--as more and more outstanding black-and-white cameramen familiarize themselves with color camerawork--it will be realized that Technicolor photography is not a mysterious secret but a simple matter of applying the same basic rules that we've learned

to observe in monochrome, to the end that we may get bet-
ter pictures in color.

--Volume IX, No. 8 (September 1937), pages 24-25.

INDEX